BOOMERS 101

The Definitive Collection

———

Jodi Lipson: Director, AARP Books
Scott A. Davis: Creative Director
Michael Wichita: Director of Photography
Susan Carol McCarthy: Researcher and Writer
Betsy Holt: Editor

———

Published by AARP
601 E Street NW
Washington, DC 20049
www.aarp.org/bookstore

———

AARP publishes a variety of print and e-books.
Visit www.aarp.org/bookstore.

———

The Library of Congress Control Number: 2014912675
Manufactured in the United States of America
ISBN: 978-0-692-02972-5

"The Great American Boom is on."

SO DECLARED *FORTUNE MAGAZINE* IN THE SUMMER OF 1946, less than a year after World War II had ended. Soldiers came back to jobs, homes, and white picket fences. Birth rates spiked. From then until 1964, more than 76 million babies were born. The boomer generation.

If you're one of them, shut your eyes for a few seconds and ask: What people and things define our generation?

When boomers reminisced on social media and beyond, they suggested thousands of ideas: Hula hoops and GI Joes. Pop-Tarts and Twizzlers. JFK and MLK. Bell bottoms and go-go boots. Sonny and Cher. Lennon and McCartney. Eight tracks and 45s. Protest and free love.

We culled the top 101 heartstring-pingers. This book is that collective, definitive boomer response.

What's in your boomer collection?
Tell us on Twitter.com/aarp and Facebook.com/aarp #Boomers50

Afro

In the '60s, many blacks like
civil rights activist Angela Davis embraced
a more free and natural hairstyle. Rejecting the
tight braids and caustic hair-straightening treat-
ments that African Americans had been using
since slavery, they created the Afro,
or 'fro, with a wide-toothed pick.

The Afro was more than hair; it was the symbol of Black pride, a silent affirmation of African roots and the beauty of Blackness. —Bebe Moore Campbell

American Bandstand

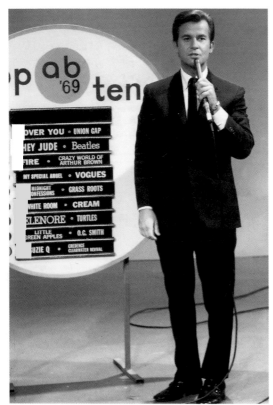

The Twist, Mashed Potato, and Bop: On weekday afternoons, 20 million viewers watched Dick Clark's *American Bandstand,* where Paul Anka, Frankie Avalon, and Connie Francis lip-synced their latest hits. Fans loved Rate-a-Record, when teens ranked new songs, routinely saying, "It's got a good beat and you can dance to it."

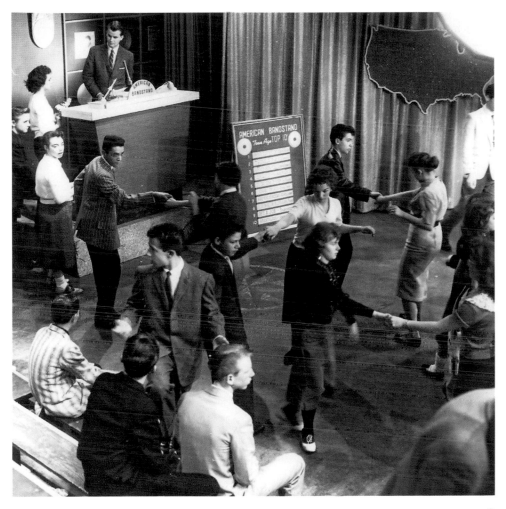

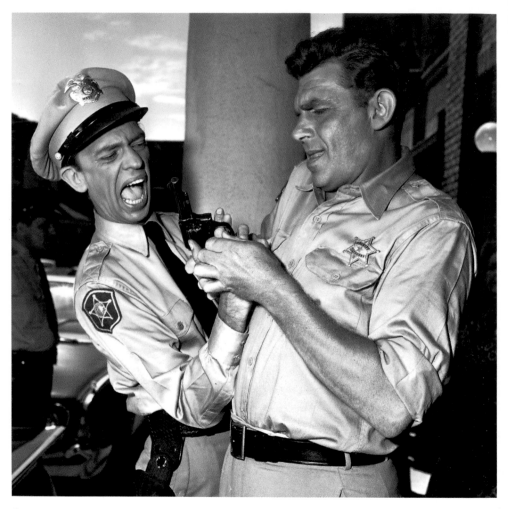

Andy Griffith Show

The little town of Mayberry was filmed on MGM sets left over from *Gone With the Wind.* Andy Griffith, a successful comedian, debuted as the funny man, switching with Don Knotts' high-strung Barney Fife to become the philosophical straight man in season two.

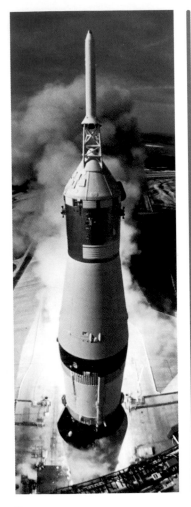

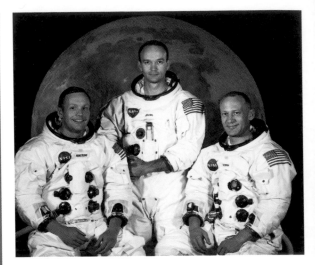

Apollo 11

President Kennedy's 1961 dream—
"We choose to go to the moon!"—finally
came true on July 20, 1969, when Apollo
11 astronauts Neil Armstrong (above left)
and Buzz Aldrin (right) landed on the
lunar surface. Michael Collins (center)
stayed in the command module.

That's one small step for man, one giant leap for mankind.

—Neil Armstrong

Banana Seat Bicycles

In 1963, Schwinn engineer Al Fritz took a simple bike and added high-rise, ape-hanger handlebars, a long bucket saddle, a three- or five-speed stick shift, and racing Slik tires. The Schwinn Sting-Ray was the best-selling bike of all time. It also became a wheelie-popping gateway for a new generation of drag racers and BMXers.

11

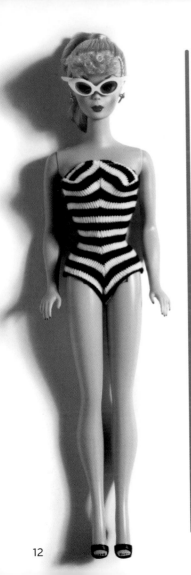

Barbie

With her designer wardrobe, Dream House, and handsome boyfriend, Barbie was every little girl's dream—and the best-selling doll ever. She once foolishly lamented, "Math is tough," but then became, in different incarnations, a NASA astronaut and a successful entrepreneur. She turned 55 in 2014, with her anatomically precarious 36-18-33 figure still perched on stiletto-ready feet.

Auction Figures

Ruth Handler, the dolls' creator, named them after her own kids, Barbara and Kenneth. The original 1959 Barbie cost $3. A billion dolls later, it sold on eBay for $3,500.

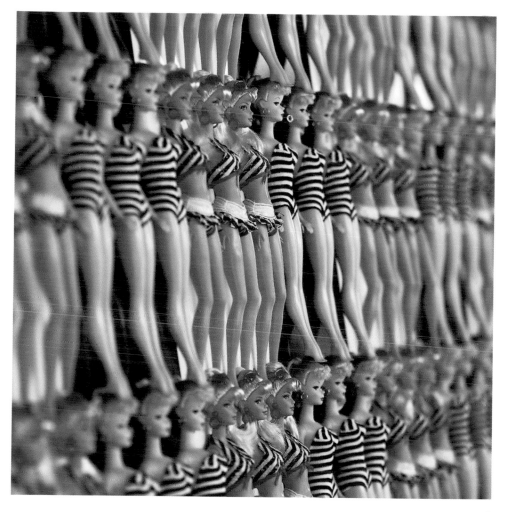

Beach Boys

Brian Wilson took a couple of his brothers,
a cousin, and a pal and built a signature sound
derived from his love for barbershop quartet
harmonies. The group evolved from simple "surf
music" (though there was but one surfer among
them) to more complex emotions and musical
arrangements like "Good Vibrations."

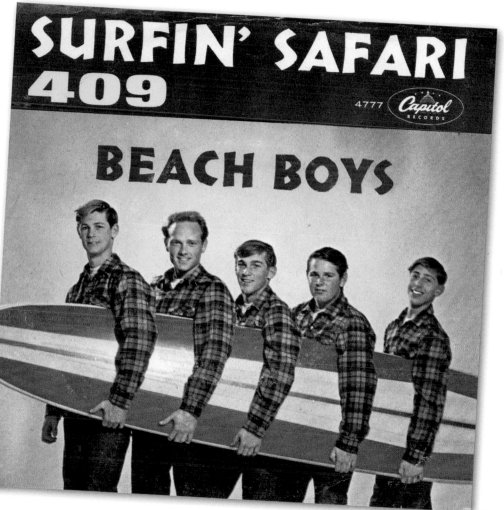

SURFIN' SAFARI
409

4777 Capitol RECORDS

BEACH BOYS

15

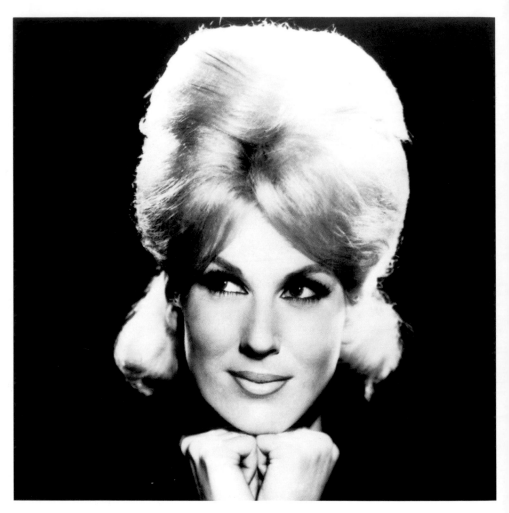

16

Beehive
Hairdo

In 1960, *Modern Beauty Shop* magazine asked stylist Margaret Vinci to create "a new hairstyle for the new decade." Inspired by a velvet fez hat with two embroidered bees, Vinci's beehive set the world, well, abuzz. On Audrey Hepburn, the style was chic; on Brigitte Bardot, sexy; and on Dusty Springfield (left), cool.

Bell Bottoms

The Navy introduced bell bottoms, which were easy to roll up and keep dry when swabbing the deck, or to remove if a sailor fell overboard. In the late '60s, hipsters adopted the style, buying them from army-navy surplus stores and embroidering them with flowers and peace signs as an anti-war statement. Flashier bell bottoms became synonymous with the disco fashions of the '70s.

Bell Bottoms and Long, Beautiful Hair
The musical *Hair* (right) reflected the styles of the day—not to mention anti-war sentiment.

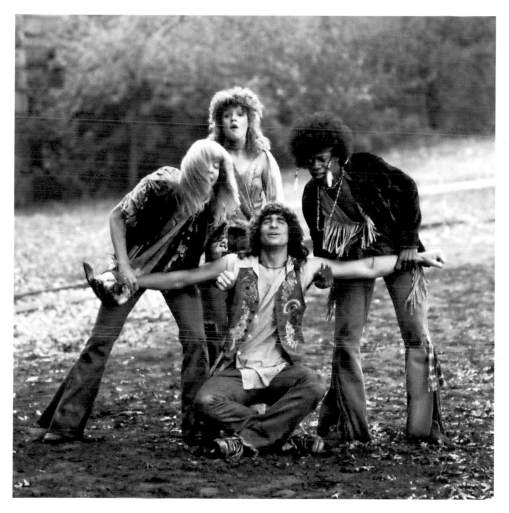

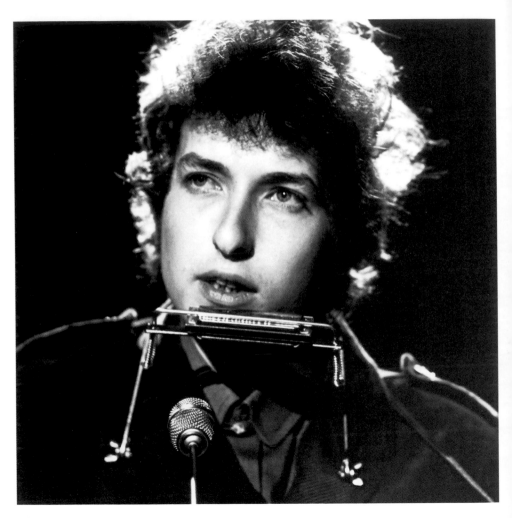

Bob Dylan

The original "Mr. Tambourine Man" was considered the definitive folksinger and songwriter of the '60s protest movement, penning such classics as "The Times They Are A-Changin'." In the 50 years since, Dylan has had Grammy-winning hits in rock, pop, blues, country, and folk, and won an Oscar for his song In the 2001 movie *Wonder Boys*.

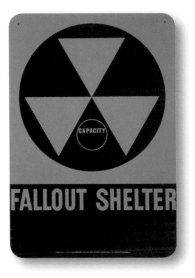

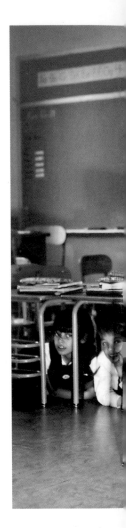

Bomb Shelters

In the early '60s, the Cold War turned hot. President Kennedy urged Americans to "take steps to protect your family in case of a nuclear attack." In schools, Bert the Turtle cartoons taught children to duck and cover. At home, some families built backyard shelters to protect themselves from radioactive gamma rays.

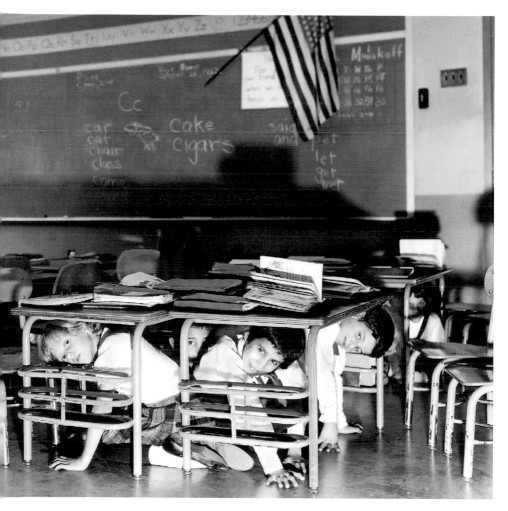

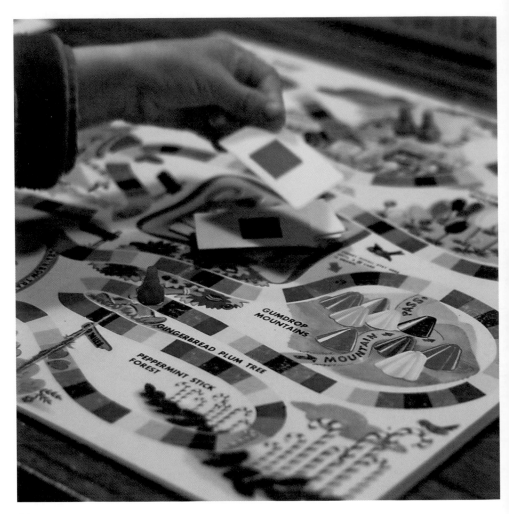

Candy Land

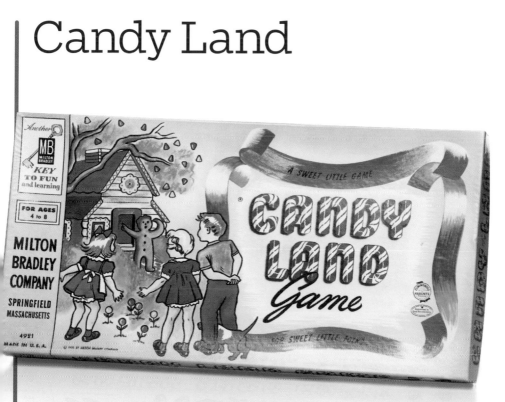

When teacher Eleanor Abbott invented
Candy Land while recuperating from polio, she
was hoping to entertain sick children recovering from
the disease and help them learn to count and take turns.
The game proved wildly popular, with 40 million sold. Today,
60 percent of households with 5-year-olds own the game.

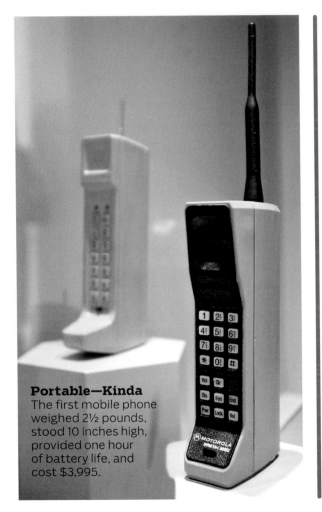

Cell Phone

Inspired by Captain Kirk's "communicator" on *Star Trek,* Motorola engineer Martin Cooper (right) created the first cell phone in 1973. To the bewilderment of passersby, he stood on a New York street corner and made his first call: to rival Joel Engel at AT&T's Bell Labs.

Portable—Kinda
The first mobile phone weighed 2½ pounds, stood 10 inches high, provided one hour of battery life, and cost $3,995.

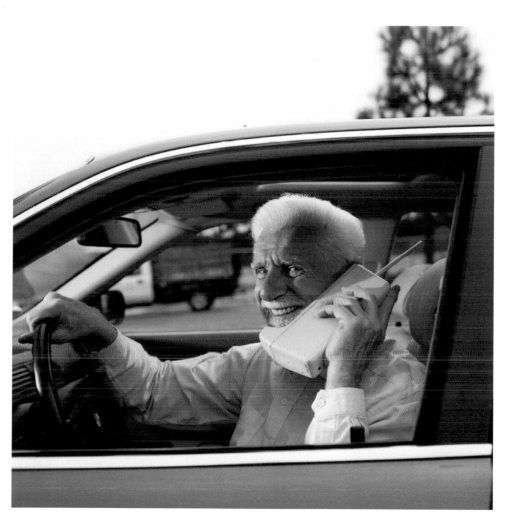

Chatty Cathy

The second most popular doll of the '60s (after Barbie) was Mattel's Chatty Cathy. "Just pull the ring, and she'll say 11 different things!" the commercial promised. With the help of a needle, record, and tiny turntable, the doll said things like, "Please brush my hair," "May I have a cookie?" and "Let's have a party!"

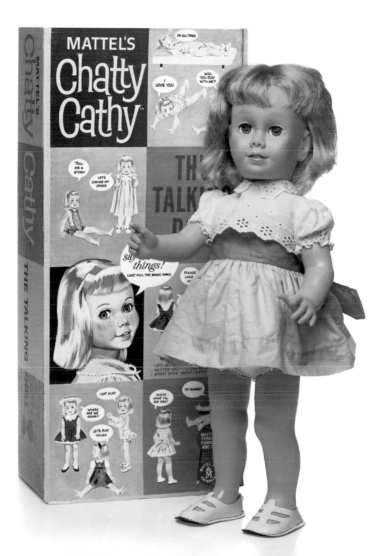

Computer

The first computer weighed 30 tons, sprawled 2,000 square feet, and calculated missile trajectories in 30 seconds. It took several more breakthroughs—Bell Labs' 1948 miniature transistors, Texas Instruments' 1958 integrated circuits, and Intel's 1971 microprocessor—to create a desktop computer.

Apples to Oranges
Both Mac and PC devotees can thank the world's two most successful college dropouts—Steve Jobs and Bill Gates—for the creative rivalry that spurred the computer revolution.

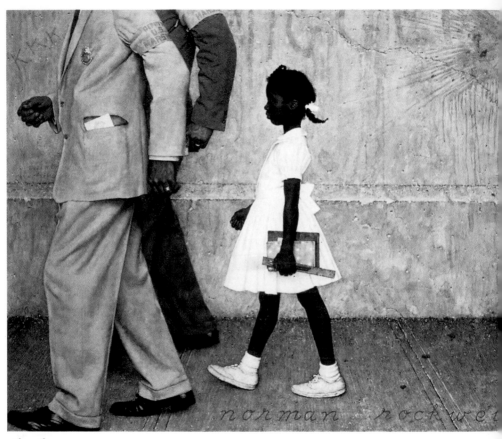

" We preach freedom around the world...but are we to say to the world, and much more importantly, to each other, that this is a land of the free except for Negroes? "

—President John F. Kennedy

Desegregation

The Supreme Court's 1954 decision in *Brown v. Board of Education* launched the civil rights movement. Desegregation had a radical, far-reaching aim: to end the inequality inherent in "separate but equal" facilities, whether public schools, accommodations, or drinking fountains. School integration, amid protest, inspired Norman Rockwell's "The Problem We All Live With" (left).

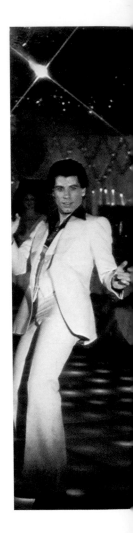

Disco Fever

Growing out of groove and funk, disco (named after the French *discotheque*) ruled dance clubs in the early '70s. Many people thought disco was dead by 1976, but *Saturday Night Fever* (1977) kept the music "Stayin' Alive," turning TV heartthrob John Travolta into a superstar and spawning the best-selling soundtrack of all time.

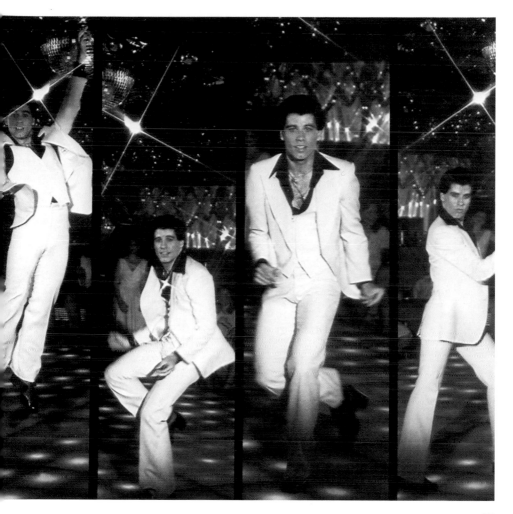

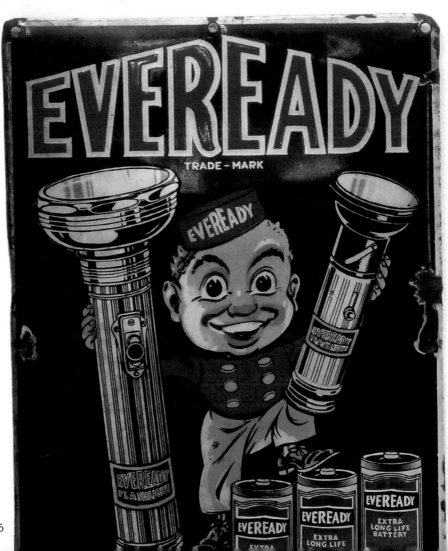

Disposable Batteries

After Eveready invented the world's first miniature battery in the late '50s, most of the world stopped winding their watches, and hearing aids shrunk. Cylindrical alkaline batteries soon followed, powering up all sorts of things that beeped or blinked: transistor radios, motorized dump trucks, flashlights, and Magicube flash bulb cameras.

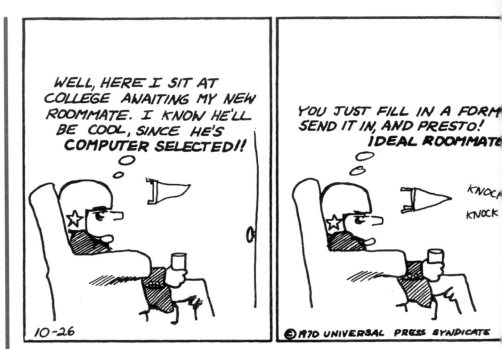

Doonesbury

Launched as *Bull Tales* in the *Yale Daily News,* Garry Trudeau's *Doonesbury* comic strip went national in 1970. The title combined *doone* (slang for a clueless person) with Pillsbury (Trudeau's college roommate). Trudeau has chronicled the cartoon's 90-member cast from college to the golden years—and drawn love, hate, and a Pulitzer along the way.

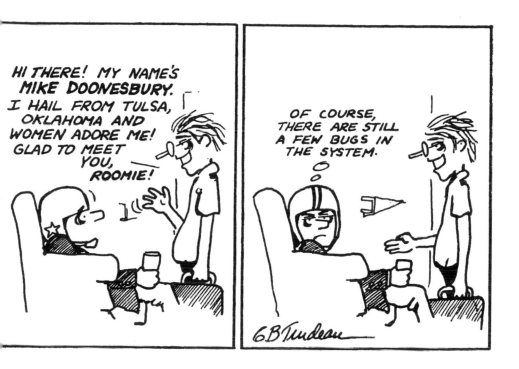

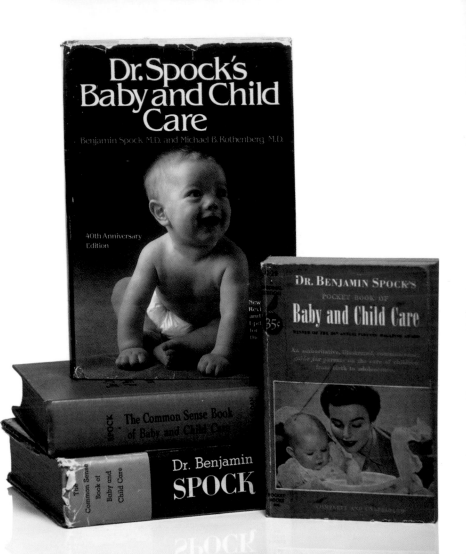

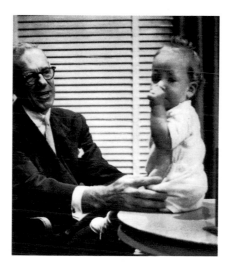

Dr. Spock

The same year the baby boom began, 1946, Dr. Benjamin Spock (above) published *Baby and Child Care.* His advice was revolutionary: Hug your children. Tell them they're special and loved. Feed them when they're hungry. Use words, not physical punishment, to discipline. For 52 years, only one book outsold Dr. Spock's—the Bible.

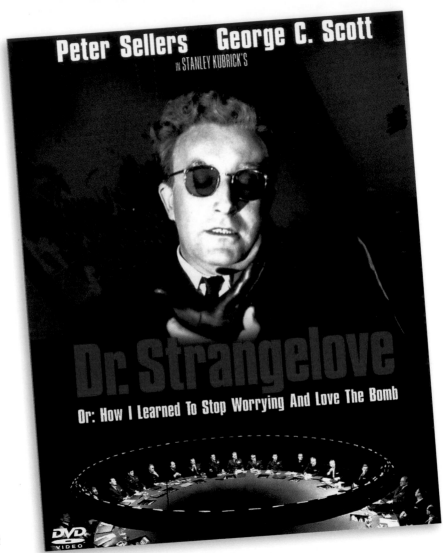

42

Dr. Stangelove

In Stanley Kubrick's 1964 Cold War satire,
comic Peter Sellers embodied the nation's
nuclear paranoia and skewered the military
strategy of MAD (mutually assured destruc-
tion). The American Film Institute ranks
Dr. Strangelove #3 on its list
of 100 Funniest Films.

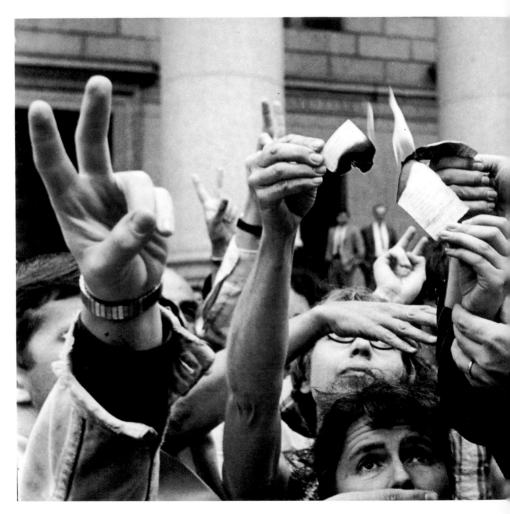

Draft Cards

From 1917 to 1973, young men holding draft cards were conscripted into the military. During the Vietnam era, 1,728,344 draftees were selected by lottery to serve. In 1965, pacifist David Miller was the first to burn his draft card. He was imprisoned for two years.

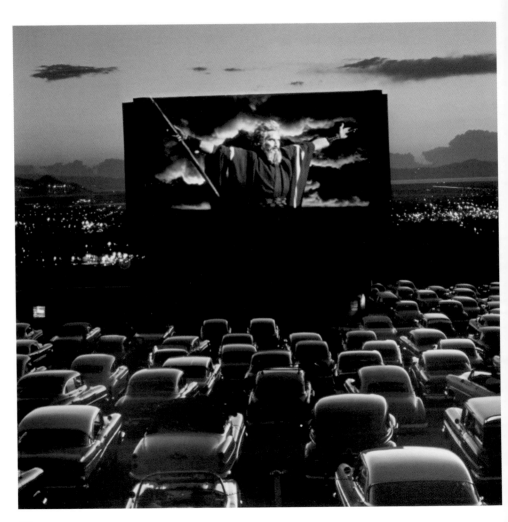

Drive-In Movies

"The whole family is welcome, regardless of how noisy the children are," advertised the first drive-in movie theater, in Pennsauken, New Jersey. At their peak in the '50s, some 4,000 drive-ins touted, "Save while you spend" and, perhaps more important, "Leave your girdle at home." Teen boomers helped drive-ins earn their '60s nickname: "passion pits."

Can You Hear Me Now?
The earliest drive-in speakers were bullhorns mounted on movie screens. In 1941, they were replaced with RCA's new "private, fully-adjustable, in-car speakers."

Easy Bake Oven

When Norman Shapiro, a sales rep
for Kenner Products, noticed New York City
street vendors using heat lamps to warm
pretzels, an iconic toy idea was born. Since
December 1963, 23 million Easy Bake Ovens
have sold. Ads claimed the oven was "just like
Mom's—bake your cake and eat it too!"

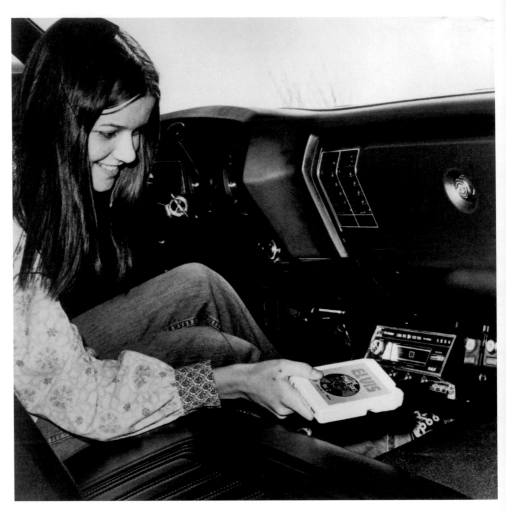

Eight Tracks

The dream of an affordable compact music-delivery system for cars came true with the eight track, based on technology developed for planes. Ford installed the players first, in the 1966 Lincoln, Mustang, and Thunderbird. Countless miles, jammed tapes, and make-out sessions later, eight tracks were rendered obsolete by CDs in the early '80s.

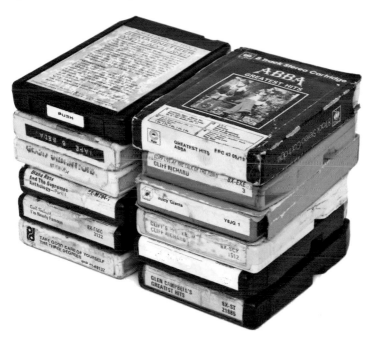

Taken by the Wind

Most experts agree the last eight-track tape commercially released was *Fleetwood Mac's Greatest Hits* in 1988.

Elvis

How does a truck driver from Tupelo, Mississippi, become the king of rock 'n' roll? Some might credit Sam Phillips of Sun Records, or Presley's manager, Colonel Tom Parker. But it could be as simple as Elvis' beautiful baritone, his roots in "black music," and the raw sexuality of those swiveling hips and the quivering lip.

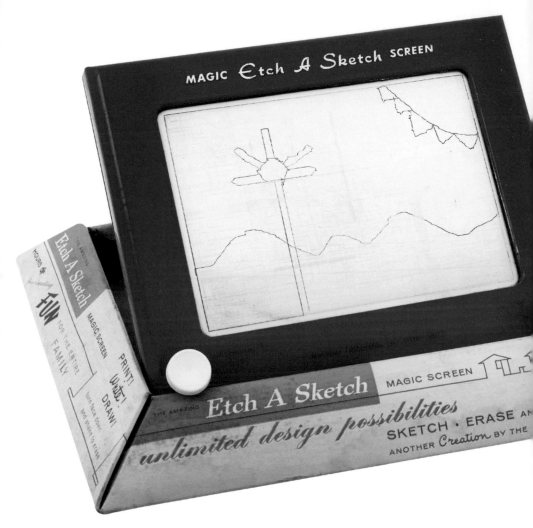

54

Etch A Sketch

"Hours of fascinating fun for the entire family," the box promised, along with "unlimited design possibilities." The Etch A Sketch, which launched Christmas 1960, became the best-selling toy of the season. Decades and 120 million magic screens later, the toy is now marketed as the world's first laptop.

Fab Four

London, 1962: The Beatles auditioned for Decca records exec Dick Rowe, who turned them down, telling their manager, "Guitar groups are on the way out, Mr. Epstein." New York, February 1964: John, Paul, George, and Ringo arrived in the United States with their #1 hit "I Want to Hold Your Hand." Two days later, they appeared in their mod suits and pudding bowl haircuts on *Ed Sullivan*. By April, they'd made history as the only band to hit *Billboard's* top five slots at once.

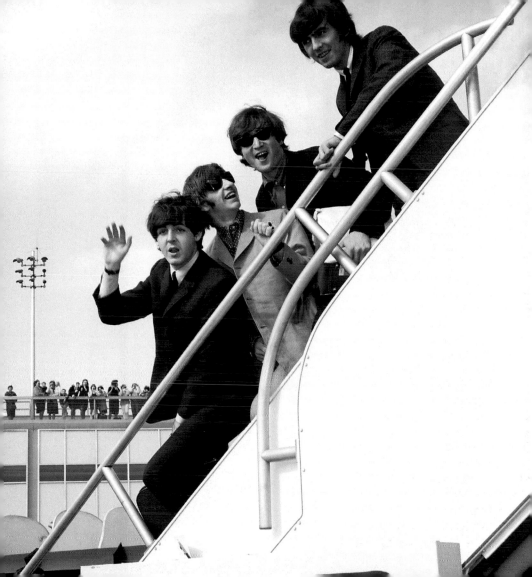

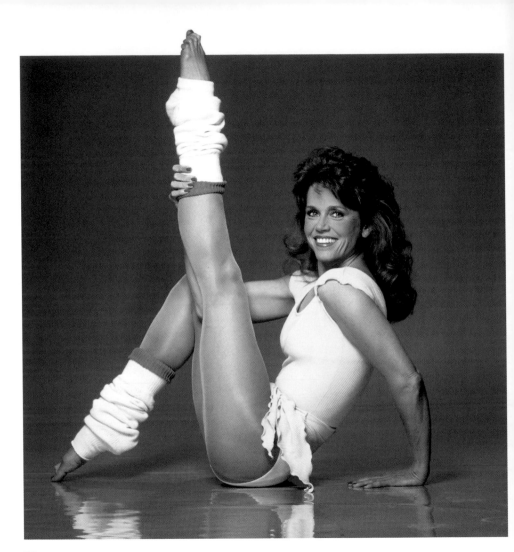

58

Fitness Craze

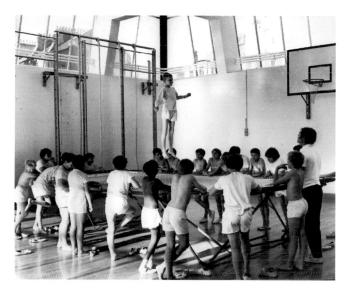

President Dwight Eisenhower established the President's Council on Fitness in 1956, kicking off the exercise craze. Then came aerobics, running, and yoga. Gym memberships, exercise videos, and boot camps. Jane Fonda, Arnold Schwarzenegger, and Richard Simmons. And spandex. Whatever it takes to, in James Brown's words, "Get up offa that thing."

Flower Power

At the University of California, Berkeley, Beat poet Allen Ginsberg suggested that anti-war protestors hand out "masses of flowers" to police officers, reporters, politicians, and spectators. By promoting positive values like peace and love over war and death, flower power came to symbolize the counterculture and anti-war movements.

Ford Mustang

Fast, powerful, reliable, and affordable, the first Mustang was immediately popular on and off the track. *Goldfinger,* in 1964, was the first movie to feature the car, followed by dozens more, including *Bullitt,* where Steve McQueen drove a Shelby GT390 in the legendary 9-minute, 42-second chase scene.

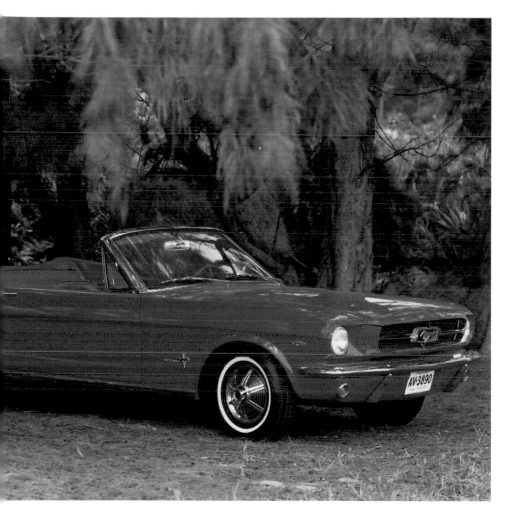

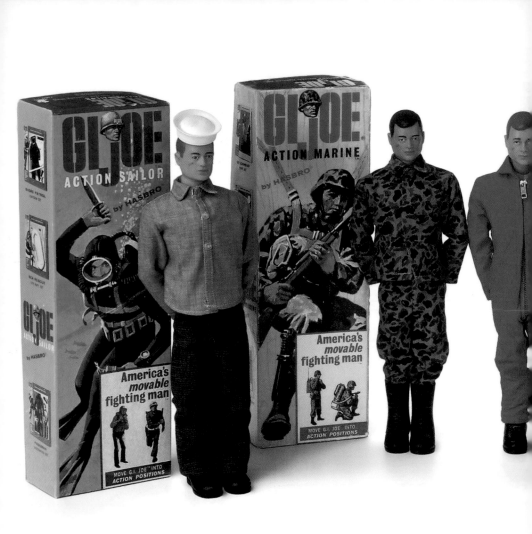

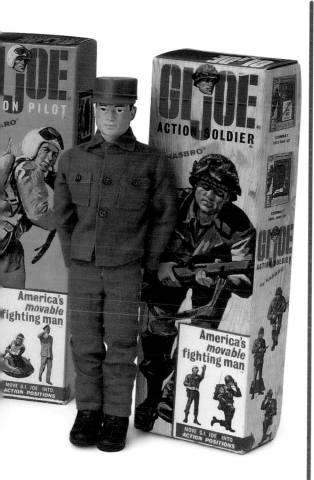

GI Joe

Noting rival toymaker Mattel's huge success with Barbie dolls, Hasbro developed a counterpart for boys—not called a "doll" (which boys wouldn't of course buy), but "a poseable action figure with 21 moveable parts." GI (Government Issue) Joe, a "fighting man from head to toe," proved immensely popular throughout the '60s.

Gilligan's Island

Sit right back and consider the cast-
away sitcom (1964-67) forever afloat
in reruns. Where did the Howells stow
enough luggage to last three years?
If the Professor could build a coconut
radio, why couldn't he fix the boat? Did
Yahoo TV viewers really vote *Gilligan's
Island* the Best TV Theme Song Ever?
(You bet, little buddy!)

The Eternal Question
Ginger or Mary Ann? The question was asked in a 1993 Budweiser
commercial. The consensus: Mary Ann. Bob Denver (Gilligan) concurred.

Boots for Our Boys

Raquel Welch performed in go-go boots for Bob Hope's 1967 Christmas special for U.S. troops in Southeast Asia. "Everything's gone up at home," Hope quipped. "Prices, taxes, and miniskirts."

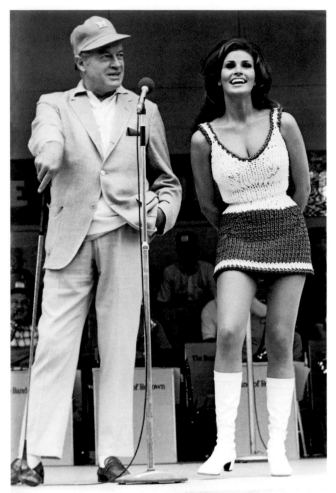

Go-Go Boots

The first go-go dancers were seen wearing miniskirts and boots, high above the dance floor of Hollywood's Whisky a Go-Go. The same year the discotheque opened, in 1964, French designer Andre Courreges introduced go-go boots. They were white, square-toed, and low-heeled. "These boots," crooned Nancy Sinatra, "are made for walkin'!"

Hair Rollers

The best way to achieve the '50s bouffant and '60s beehive was with giant hair rollers—mesh, foam, plastic, or Velcro. When straight hair became the rage in the '70s, ironing hair became the rage. Those with ultra-curly hair used beer cans for voluminous control. One coed explained, "Six beer cans, preferably empty, can do what 30 rollers used to."

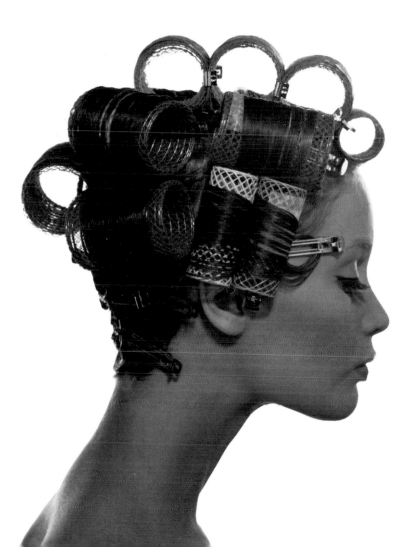

Hendrix

In just two years—between his breakout performance at the Monterey International Pop Festival in 1967 and his legendary show at Woodstock in 1969—Jimi Hendrix produced three iconic albums and transformed rock 'n' roll. The guitarist was, according to the Rock and Roll Hall of Fame, "the greatest instrumentalist in the history of rock music."

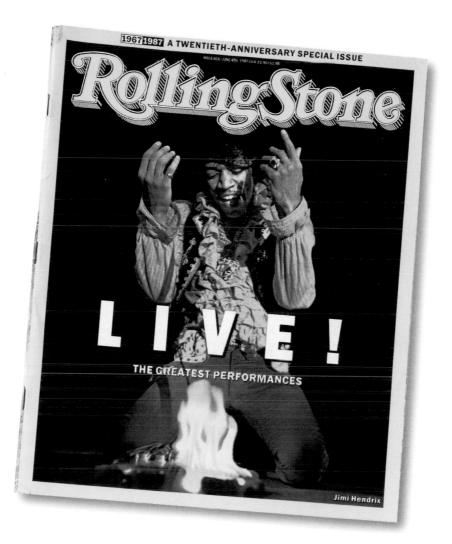

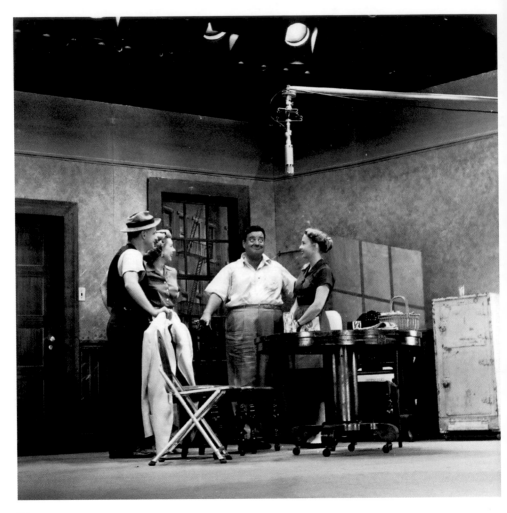

Honeymooners

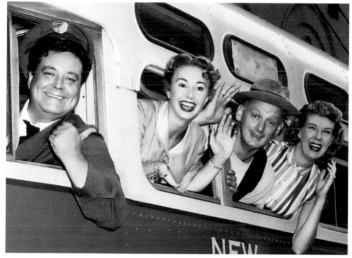

Unlike most '50s sitcoms—suburban, prosperous, and familial—Jackie Gleason's much-loved *Honeymooners* were urban, lower middle class, and childless. Ralph and Alice Kramden of Brooklyn battled regularly, often involving upstairs neighbors Ed and Trixie Norton, but the Kramdens always kissed and made up.

Hostess Twinkies

In 1930, Hostess bakery manager James Dewar had a strawberry-filled sponge cake maker that stood empty when strawberries were out of season. His inspiration—sugar-cream-filled Twinkies—became a major food group in boomer lunchboxes, along with Ding Dongs, Ho Hos, and Sno Balls. Archie Bunker called Twinkies "WASP soul food."

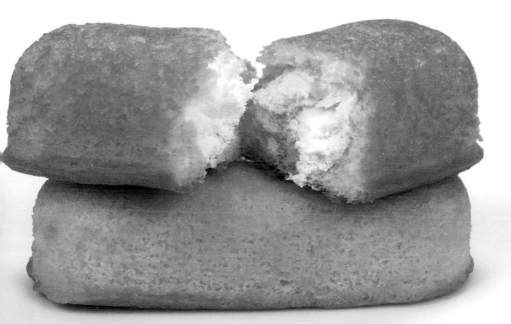

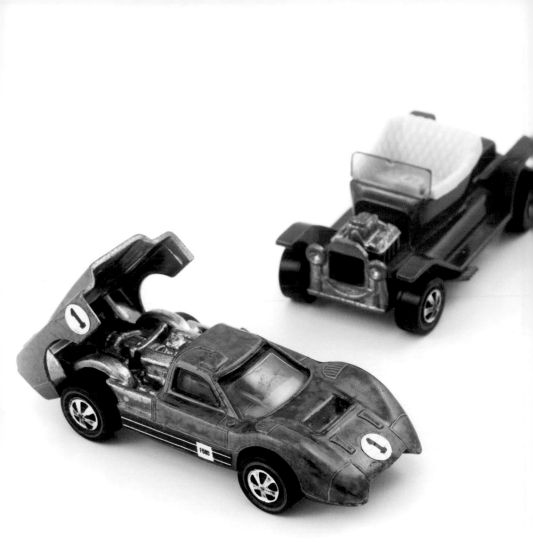

Hot Wheels

In 1968 (the year Steve McQueen's *Bullitt* practically invented movie car chases), Mattel released Hot Wheels, the world's fastest miniature metal cars. They wowed kids and wooed collectors with their dramatic designs, torsion-bar suspension, redline racing slicks, flashy paint flames, and curving, looping, ramp-jumping plastic race tracks.

Howdy Doody

Howdy Doody was the first weekday network TV show just for kids. It was also the first to air before a live audience, the first to broadcast five days a week, and one of the first to usher in color. On the show's last episode, on September 24, 1960, Clarabell spoke for the first time, saying, "Goodbye, kids."

Hula Hoop

Wham-O's big idea: Remake a popular Australian bamboo exercise hoop in brightly colored plastic and call it the Hula Hoop. Americans went crazy for it—with 100 million bought between 1958 and 1960—but not everyone agreed. The Japanese banned it because "the rotating hip movement seemed indecent," and Russians thought it showed "the emptiness of American culture."

HULA HOOP

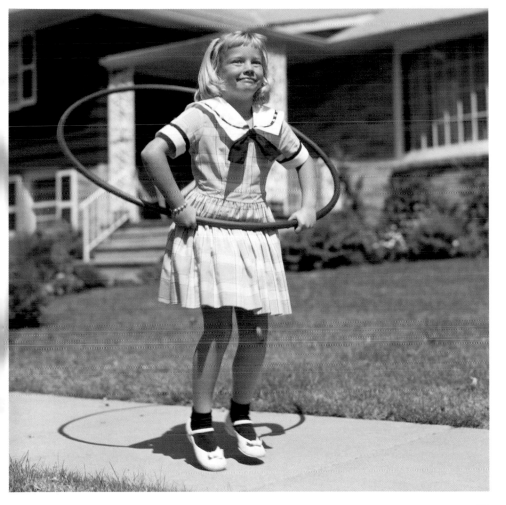

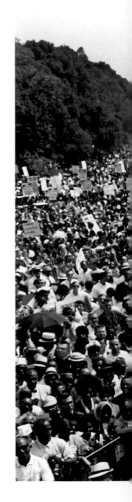

> **❝** I have a dream that my four little children will one day live in a nation where they will not be judged by the color of their skin, but by the content of their **❞** character.

<div align="right">—Martin Luther King, Jr.</div>

I Have a Dream

Barely 1,600 words, Dr. Martin Luther King, Jr.'s impassioned speech on August 28, 1963, was the pinnacle of the March on Washington for Jobs and Freedom. His words created a watershed moment in history.

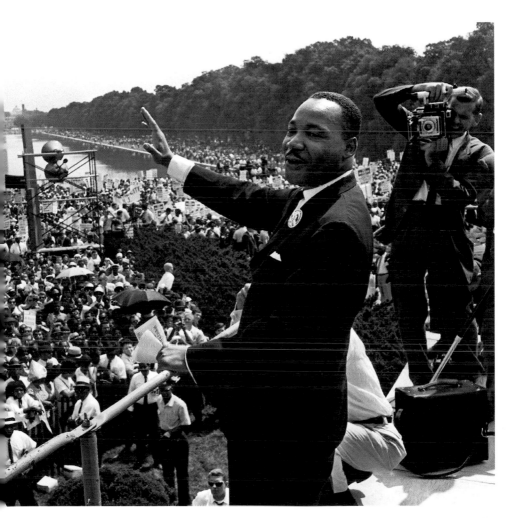

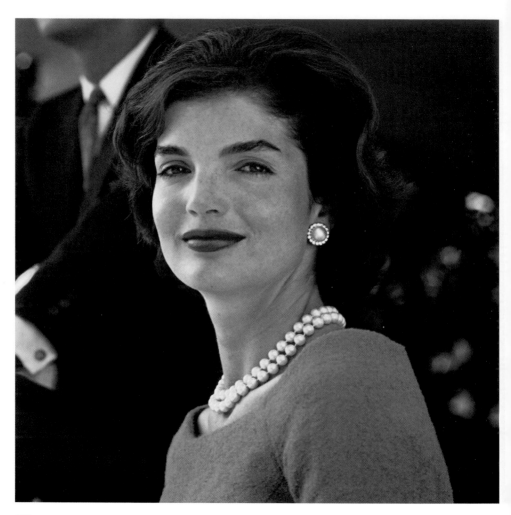

Jackie's Style

Jackie Kennedy had a style that was remarkably simple and invariably chic: solid colors, sleek shifts, Chanel suits, pillbox hats, oversized sunglasses, silk scarves, and pearls. "You could do anything for her and it would look good," said designer Oleg Cassini.

Jackson 5

When 10-year-old Michael and big brothers Jermaine, Tito, Marlon, and Jackie burst onto the Motown scene in 1970, they quickly made music history: Their first four singles hit #1 on the R&B and pop charts. A blockbuster summer tour and TV cartoon followed. As Ed Sullivan sagely observed, "The little fella in front is incredible."

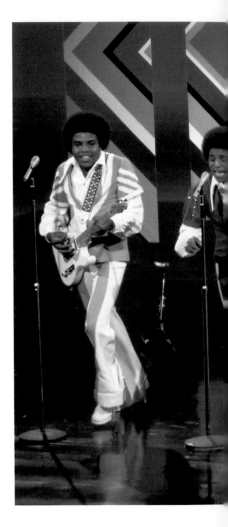

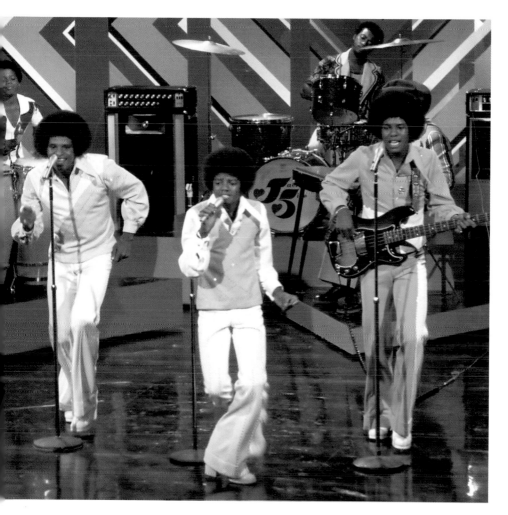

Mr. Blue Jeans
Laborers called them overalls. Boomers renamed them "jeans" in 1960.

Jeans

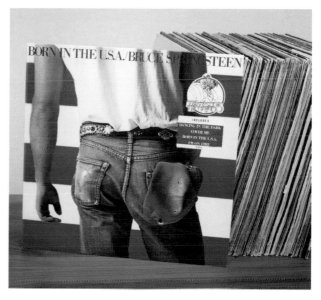

In 1872, a laborer's wife asked a tailor, Jacob Davis, to make a pair of pants for her husband that wouldn't fall apart. Davis bought denim from his supplier, Levi Strauss, and added metal rivets at points of strain, like pocket corners. After Levi's came Wranglers, Lee's, pricey designer brands...and Springsteen in his 501s.

Keep America Beautiful

The "Crying Indian" PSA featured Iron Eyes Cody, who played in three Westerns with Ronald Reagan and was committed to Native American concerns. Turns out Cody's parents were Italian—his Native heritage as fake as the glycerine tear. But the Keep America Beautiful campaign has been credited with helping to drastically reduce litter and spurring the environmental movement now embedded in U.S. culture.

Pollution: It's a crying shame

But it won't be, if we start doing something about the problems. Things as easy as using a hand mower if your lawn is small. Or not overtaxing sewage systems by running water needlessly. Or actively supporting programs to clean up our rivers, lakes and streams. Let's restore the natural beauty that was once this country.

People start pollution. People can stop it.

 Keep America Beautiful

advertising contributed for the public good

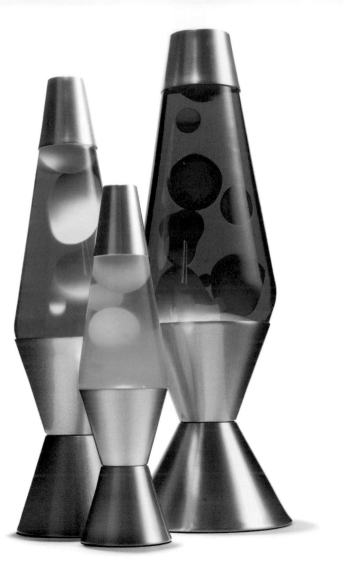

Groovy, Man
How does it work? Take two insoluble liquids—one watery, one waxy mixed with weighty solvent. Pour into a cone-shaped container. Heat with a small light bulb. Watch the wax melt, rise, cool, fall. Repeat.

Lava Lamps

Inventor Edward Craven Walker got the idea after seeing a British pub's homemade egg timer—a cocktail shaker filled with strange liquids bubbling on a stove. The Brits thought Walker's "astro lamp" made for a charming desk accessory. But America's psychedelic generation gathered round their lava lamps like a mind-expanding hearth.

Legos

The small colorful plastic bricks arrived in the United States in the early '60s. They were called Legos— from the Danish words "leg godt," which means "play well." Experts declared them the "Toy of the Century." Kids turned them into forts, castles, and skyscrapers. And parents continue to find them in the unlikeliest of places.

320 Billion
Number of individual
Lego bricks in the world
(that's 52 bricks per person
on the planet)

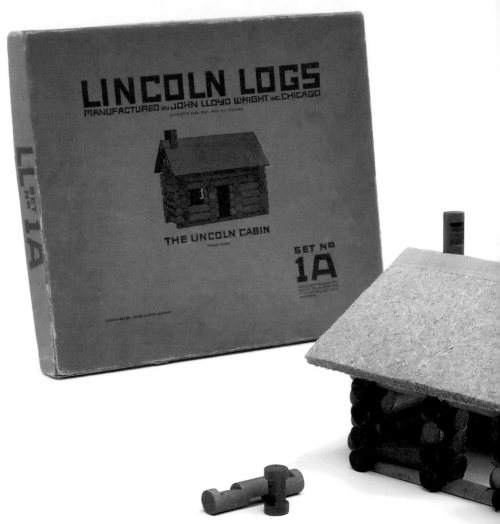

Lincoln Logs

Introduced in 1916, Lincoln Logs remained popular with boomers, who saw the toy frequently advertised on frontier TV shows like *Davy Crockett* and *Rin Tin Tin.* "Build a log cabin just like Honest Abe or Uncle Tom!" the '50s instructions said, though Uncle Tom was omitted in the more enlightened '60s.

Lone Ranger

First a radio series, *The Lone Ranger* debuted on ABC in 1949. Each week, the narrator began: "A fiery horse with the speed of light, a cloud of dust, and a hearty, 'Hi yo, Silver'—the Lone Ranger!" Millions watched the Lone Ranger and his Indian companion, Tonto, fight for "law and order in the early west."

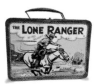

Hi Yo, Silver! Away!
The Lone Ranger survives in lunchboxes and other collectibles as well as popular catchphrases, including "What do you mean 'we,' kemosabe?" and "Who *was* that masked man?"

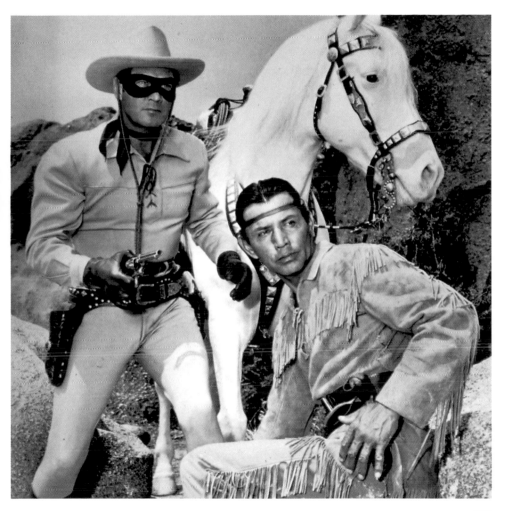

LPs & 45s

The technology was revolutionary: a flexible, spinning disc made of a new plastic material called vinyl, etched with concentric spiral grooves. The larger LP delivered up to 60 minutes, at 33⅓ revolutions per minute; the 45, a single pop song, at 45 RPMs.

The Itsy-Bitsy Spider
Did you know? Those plastic snap-in inserts that let you play singles on an LP player had a name: spindle adapters, or spiders.

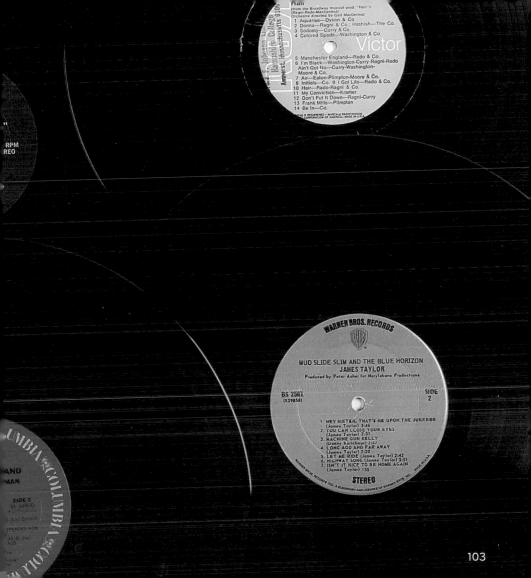

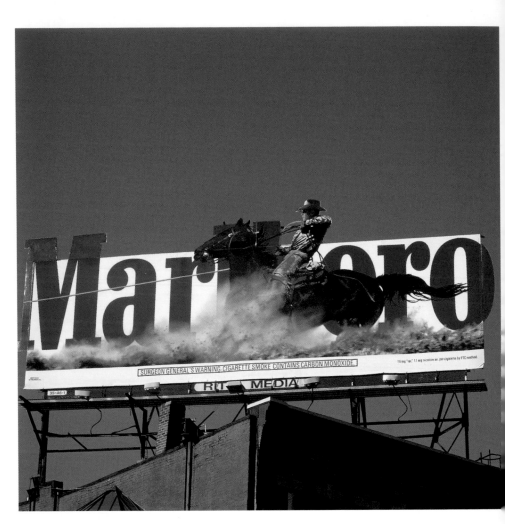

Marlboro Man

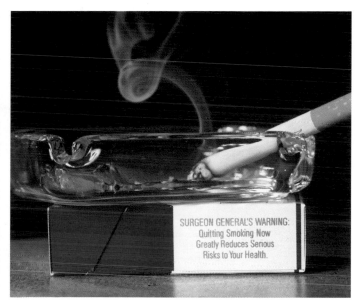

SURGEON GENERAL'S WARNING: Quitting Smoking Now Greatly Reduces Serious Risks to Your Health.

Cancer Sticks
Just 44 percent of Americans believed smoking caused lung cancer in 1958. Today, that figure is 96 percent, thanks to the U.S. Surgeon General's 1964 landmark report, warning labels, and numerous medical studies.

In the mid-'50s, Philip Morris asked Leo Burnett advertising to repackage a filtered ladies cigarette (previously marketed as "Mild as May") for men. The result: the rugged, ultra-masculine Marlboro Man. The first year, sales skyrocketed 3,241 percent. Since 1972, Marlboro has been the #1 tobacco brand in the world.

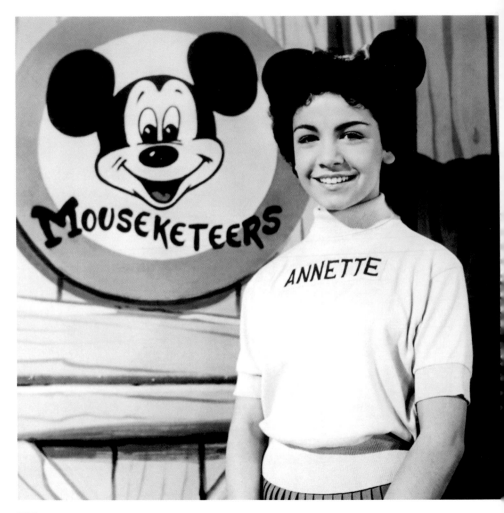

Mickey Mouse Club

Walt Disney needed $500,000 to finance Disneyland. ABC needed family programming.
In 1954, *The Mickey Mouse Club* debuted with a "Hey, there! Hi, there! Ho, there!" The show was a hit, with spinoff cartoons, serials, licensed lunchboxes, syndicated reruns, and revivals in the '70s and the '90s.

Got Ears?
Walt Disney World sells 2½ million Mouse ears every year.

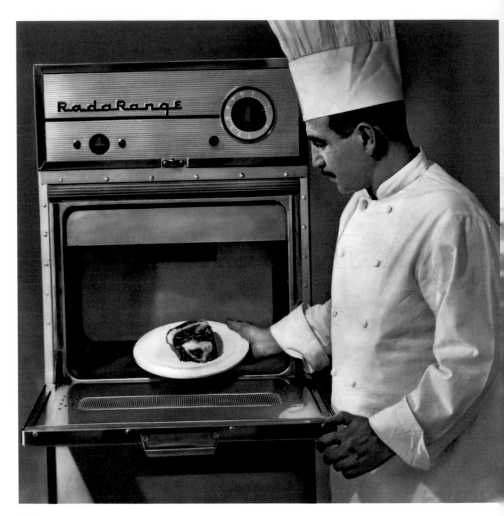

Microwave Ovens

Reaching 6 feet tall and weighing in at 750 pounds, the first microwave, the RadaRange, was sold to restaurants and ship galleys for $5,000 in 1947. Smaller ovens, made by Amana, appeared in 1967 for $495. Once people got past the unfounded rumors that microwaves could make you sterile, impotent, or blind, dinnertime was transformed forever.

The First Microwave Popcorn

In 1946, a U.S. engineer performing maintenance on a magnetron tube—which had microwave radar signals to detect enemy craft—noticed his chocolate bar had melted. Later, he aimed the tube at several kernels of corn and cooked the first microwaved popcorn.

Miniskirts

Designer Mary Quant noticed girls on London's posh King's Road wearing shorter and shorter skirts. When she included thigh-high hems in her line and named them "miniskirts," the world took notice. The short skirts (like those worn by Goldie Hawn, right, here with Dan Rowan on *Rowan & Martin's Laugh-In*) celebrated women's newly won sexual freedom. They were also an easy way for boomers to upset their parents.

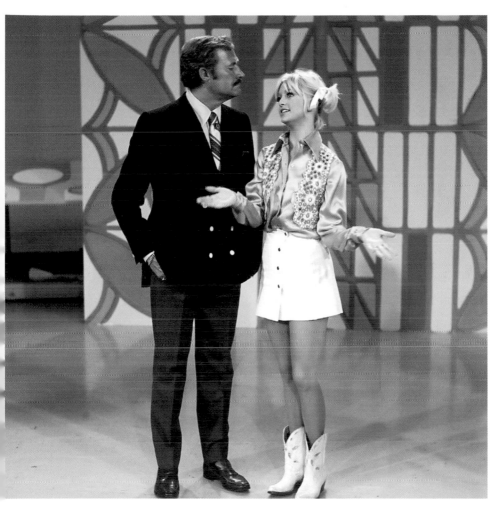

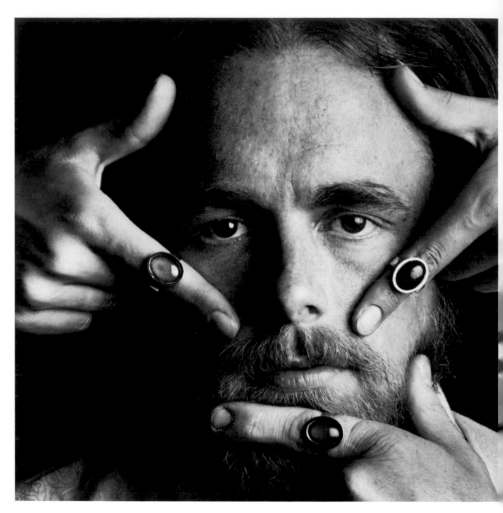

Mood Rings

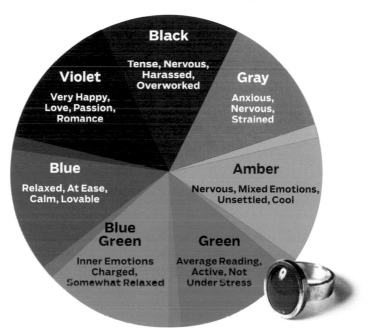

Black
Tense, Nervous, Harassed, Overworked

Violet
Very Happy, Love, Passion, Romance

Gray
Anxious, Nervous, Strained

Blue
Relaxed, At Ease, Calm, Lovable

Amber
Nervous, Mixed Emotions, Unsettled, Cool

Blue Green
Inner Emotions Charged, Somewhat Relaxed

Green
Average Reading, Active, Not Under Stress

Mood rings hit the market in 1975, with stones that changed color with body temperature—purportedly revealing the wearer's emotions. Sales topped $15 million that year, making the ring makers (Josh Reynolds, left, and Maris Ambats) a happy deep violet. By 1977, the fad had gone black.

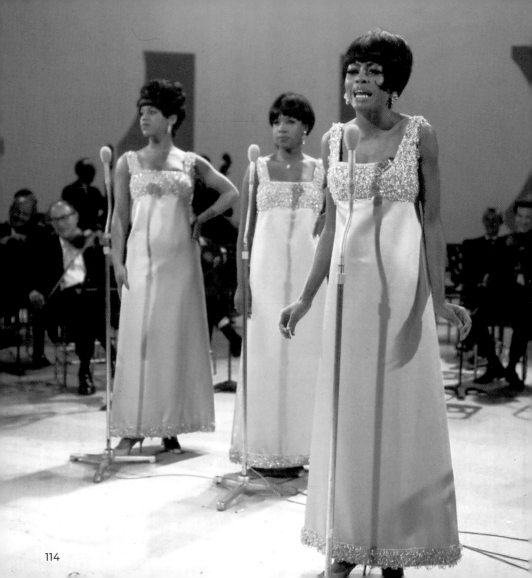

Motown

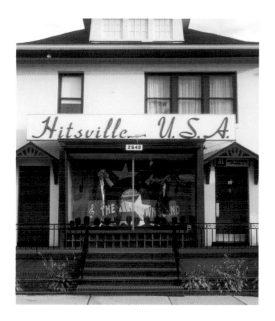

Diana Ross and the Supremes. Smokey Robinson and the Miracles. Gladys Knight and the Pips. The Temptations. It all started with autoworker and featherweight boxer Berry Gordy, who founded Motown Records in a little house that presciently boasted "Hitsville U.S.A."

Mr. Potato Head

Originally a set of pointy facial features that kids could jab into a real potato, Mr. Potato Head was the first toy advertised on TV. He married on Valentine's Day 1954 and got a plastic body in 1964. Surrendering his pipe in 1986, he became "spokespud" for the Great American Smokeout campaign.

In the Spud-light
Mr. Potato Head has starred in *Toy Story,* floated in Macy's Thanksgiving Day parade, and appeared in a Bridgestone Tires Super Bowl commercial.

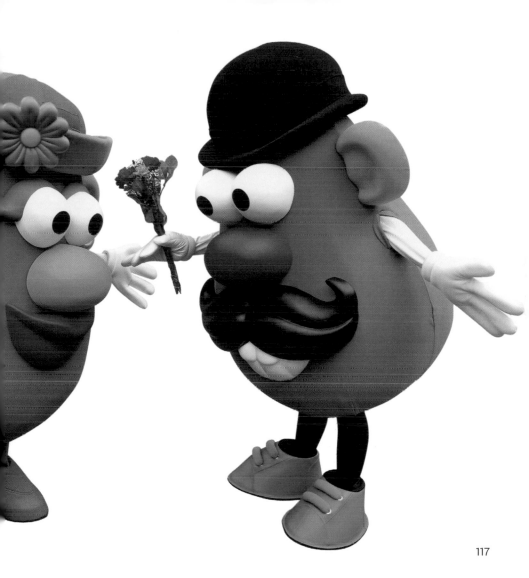

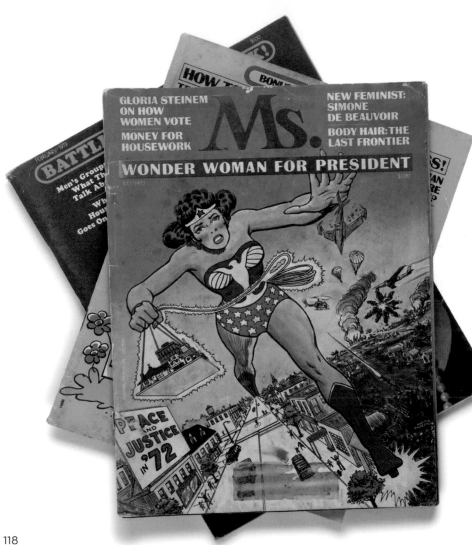

Ms. Magazine

In 1972—when many women couldn't get credit or rent an apartment without a man's signature and most jobs were listed as "Help wanted, male"—a group of feminists led by Gloria Steinem published the first magazine for women, written by women. The first issue of *Ms.* sold out in eight days.

Muhammad Ali

At 22, Cassius Clay gave new meaning to the term "brash" when he stunned the world and beat heavyweight boxing champion Sonny Liston. Clay later embraced Islam, changed his name to Muhammad Ali, went to jail for refusing the draft, and became a global ambassador for peace.

> I am the greatest. I said that even before I knew I was.
>
> —Muhammad Ali

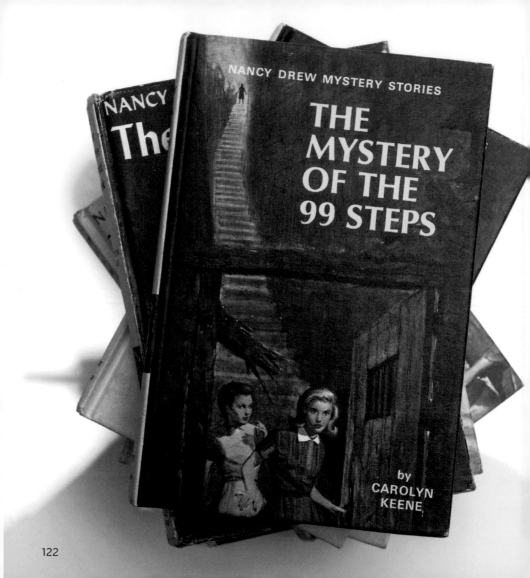

Nancy Drew and the Hardy Boys

Boomers learned to read with Dick and Jane, but they learned to *love* to read with the Hardy Boys and Nancy Drew. Frank and Joe Hardy, their detective dad often gone, were left to solve the mysteries. Spunky Nancy Drew, sleuthing with her crew, couldn't be out-smarted. The Statemeyer literary syndicate created both series, written since by ghostwriters.

Partridge Family

Inspired by the Beatles, the Screen Gems production company created the Monkees in 1966, a made-for-TV band. Two years later, the company created the Partridge Family, a made-for-TV family band, after meeting the Cowsill family. Unlike the Monkees, who were singers, the only members of the Partridge Family who didn't lip-sync were Shirley Jones and David Cassidy.

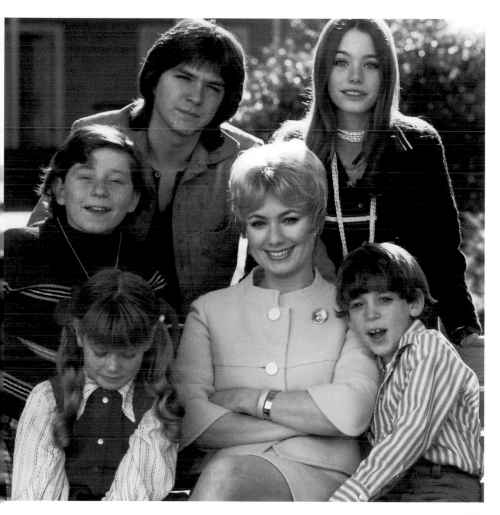

125

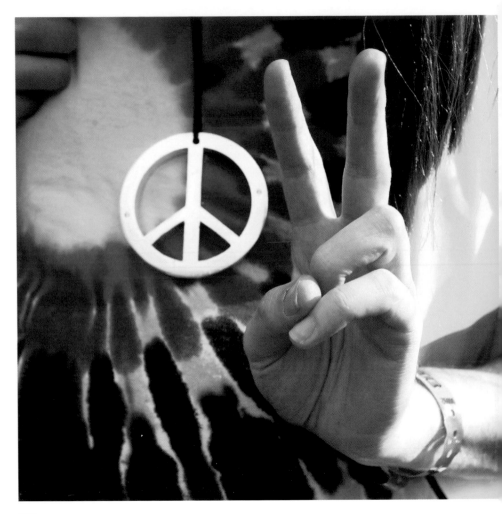

Peace Sign

Gerald Holtom, a British artist and conscientious objector in World War II, created a symbol for a 1958 nuclear disarmament march in England. Using the flag signaler's alphabet, he superimposed the letter "N" (two flags low, left and right) over "D" (one flag up, one down) inside a circle signifying the earth.

Peanuts

In 1950, Charles Schulz submitted his comic strip *Li'l Folks* to the United Feature Syndicate, which liked everything—long-suffering Charlie Brown, his vivacious dog Snoopy, Linus, Lucy, and the rest—except the name. "*Li'l Folks* is too close to *Li'l Abner*," the syndicate said, and renamed it *Peanuts* after Howdy Doody's Peanut Gallery.

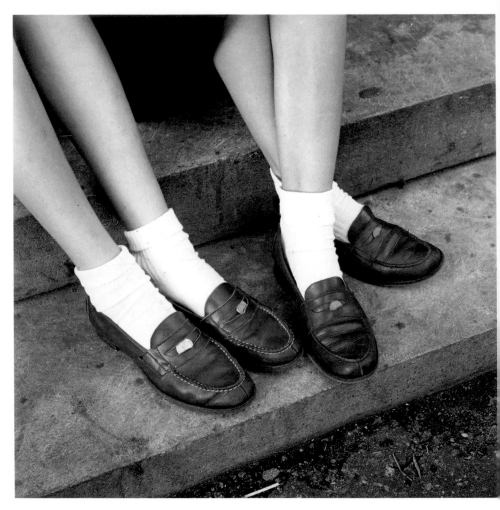

Penny Loafers

When *Esquire* ran a feature on Norwegian dairy farmers, shoe designers noted the farmers' distinctive leather slip-ons. G. H. Bass created Weejuns (after Norwegian) and added a lip-shaped opening on the cross-bands, inspired by his wife's kiss. Boomers slipped a penny into each opening, and later a dime, so they could use a payphone.

Pet Rock

It was another ridiculous boomer fad that made another inventor ridiculously rich. The $3.95 pet rock was just a rock, in a box, with a clever "owner's manual" outlining its "care." Though the fad lasted less than a year, idea-man Gary Dahl sold over 2½ tons of rocks.

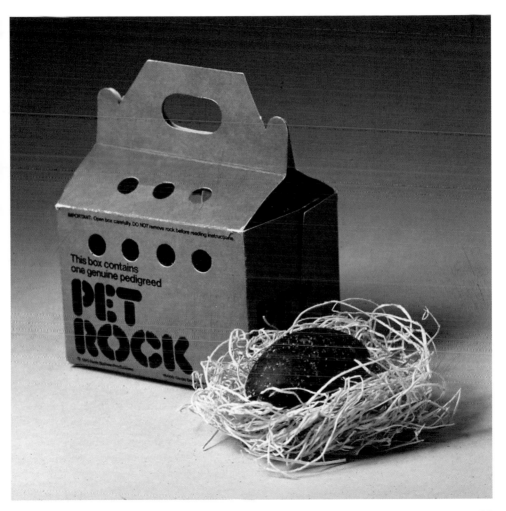

IMPORTANT: Open box carefully. DO NOT remove rock before reading instructions.

This box contains
one genuine pedigreed

**PET
ROCK**

133

Maximum Exposure
After the first Peter Max poster sold 8 million
copies worldwide, 72 companies began licensing his designs.
They have graced everything from postage stamps to pantyhose.

Peter Max

Though classically trained, Peter Max relied less on paint than on the four-color web printing presses. Starting with his original art, Max mixed colors on press, creating radical, revolutionary, psychedelic art posters that wallpapered a generation of art galleries and dorm rooms.

The Pill

On May 9, 1960, the FDA approved Enovid, granting U.S. women greater reproductive freedom. Critics worried, "Doesn't the pill promote promiscuity?" but *Time* reported, "The consensus among both physicians and sociologists is that a girl who is promiscuous on the pill would have been promiscuous without it."

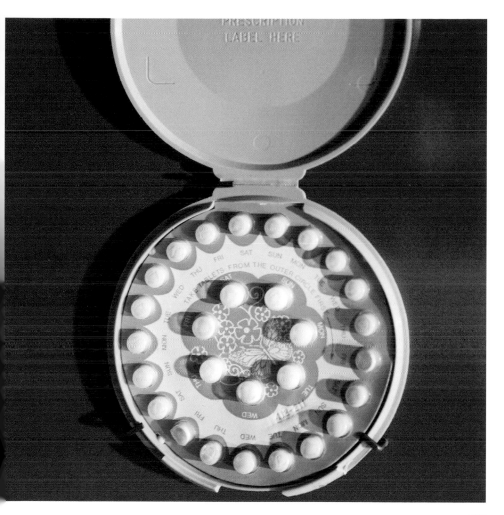

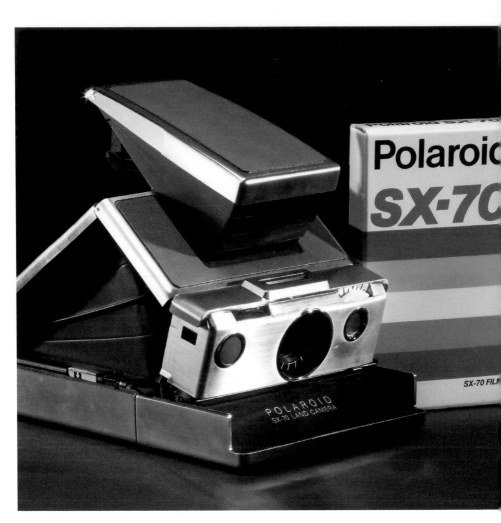

Polaroid

On a family vacation to Santa Fe, three-year-old Jennifer Land asked impatiently, "Why do we have to wait for the photo?" Her father, physicist Edwin Land, pondered the question and, in 1948, invented the Polaroid Land Camera.

Fine Photography
Notable artists and photographers like Ansel Adams, Walker Evans, David Hockney, and Andy Warhol (above) turned their Polaroid images into fine—and very expensive—art.

Pong

Pong was created at an upstart tech firm, by a new hire tackling his first training exercise: to program a two-person video game based on ping-pong. Designed in 1972 by Al Alcorn for Atari, Pong helped launch the video game craze—first in bars and arcades, and later at home with the Atari 2600.

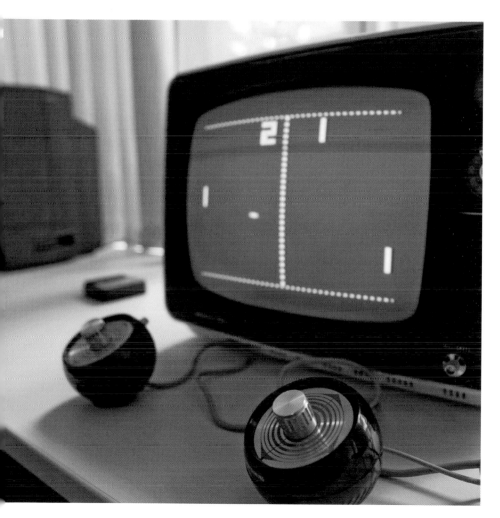

Pop-Tarts

What's in a name? When it comes to toaster pastries, everything. Six months before Kellogg's introduced Pop-Tarts, Post Cereals launched a similar product called Country Squares. In 1964, a "square" was a boring and backward person. In contrast, Pop-Tarts—a play on Andy Warhol's Pop Art—were innovative and hip. Pop-Tarts became, and remain, an American favorite.

Rainbow Flag

In '60s world peace demonstrations, marchers often carried a "Flag of the Human Race" with red, black, brown, yellow, and white horizontal stripes. A decade later, inspired by the peace flag, San Francisco artist Gilbert Baker created a "Rainbow Flag" with colorful stripes to represent the diversity and unification of the LGBT community.

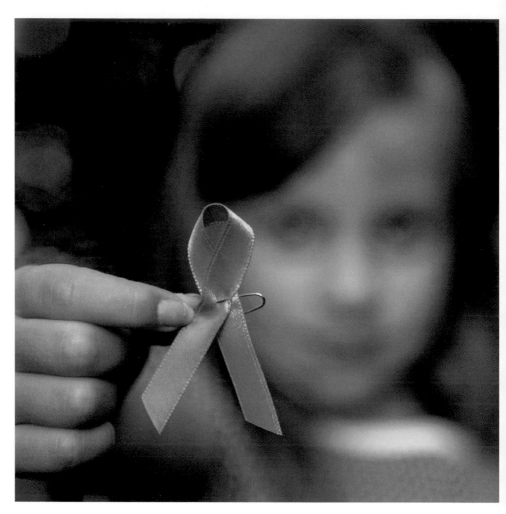

Ribbons

In 1991, a group of artists came up with a simple idea to raise awareness of HIV: a red ribbon. The ubiquitous pink ribbon for breast cancer awareness followed, as did ribbons for all sorts of causes and conditions in a rainbow of colors—from white for adoption and postpartum depression to black for melanoma and POW/MIAs.

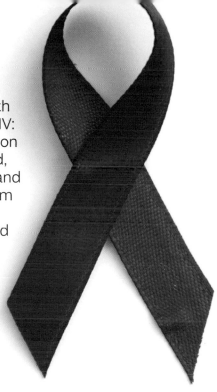

Roller Skates

When moms insisted their children "go outside and play," boomer kids strapped their skates over their shoes, tightened the toeholds with the skate key, and sped off. No knee pads, no elbow pads, and definitely no helmet. Nothing but the deafening sound of metal wheels ruling the sidewalk. Teens graduated to shoe skates in indoor rinks— and surreptitious hand-holding.

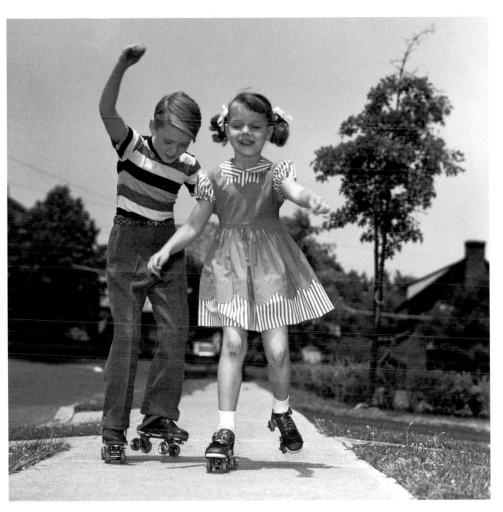

Saturday Night Live

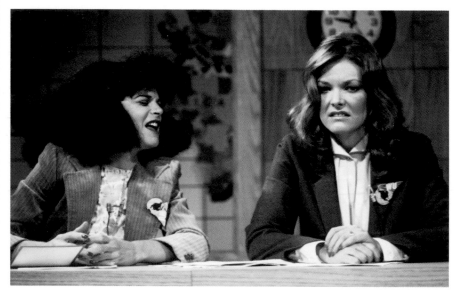

"Live from New York!" *Saturday Night Live* debuted (in Carson's *Tonight Show* slot) on October 11, 1975. Lorne Michaels cast comedians like Jane Curtin (above right), who played straight woman to Gilda "Roseanne Roseannadanna" Radner on Weekend Update. *SNL* became the most nominated show in Emmy history, with 40 awards and 156 nominations—and counting.

Ready or Not!
The original cast members from left to right: Laraine Newman, John Belushi, Jane Curtin, Gilda Radner, Garrett Morris, Dan Aykroyd and Chevy Chase

Silly Putty

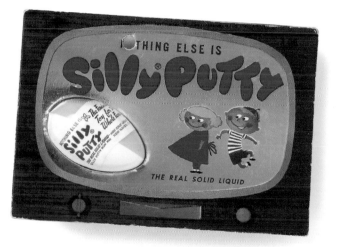

The byproduct of a wartime search for synthetic rubber, this goop was considered useless—until a savvy toymaker placed it inside a plastic egg and marketed it for Easter. Silly Putty was fun to bounce, stretch, lift images off comic strips, and clean typewriter keys. Apollo 8 astronauts even used it to hold tools in space.

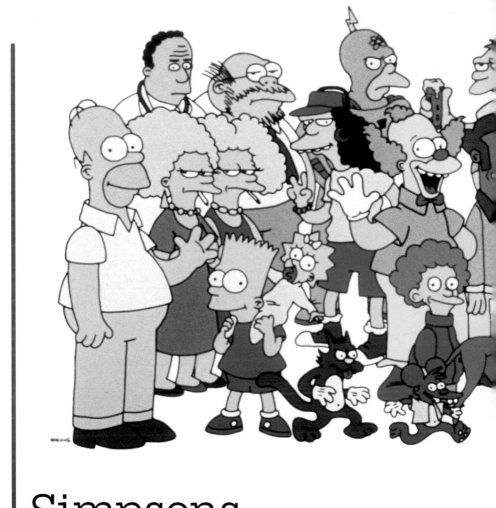

Simpsons

"D'oh!" With his strange cast of characters, Matt Groening turned the first fully animated sitcom since *The Flintstones* into a hit. Critics raved that *The Simpsons* were "not only exquisitely weird but as smart and witty as TV gets." It's the longest-running comedy on TV.

155

Slinky

"What walks down stairs, alone or in pairs, and makes a slinkety sound?" went the jingle, but it was probably the footage of a simple 80-foot wire coil slinking down steps that helped sell 300 million. Fun—but practical, too: in Vietnam as radio antennae, on space shuttles in zero-gravity physics experiments, and in high school classrooms to teach waves and sounds.

Unwound
Stretched flat, today's standard Slinky measures 87 feet long.

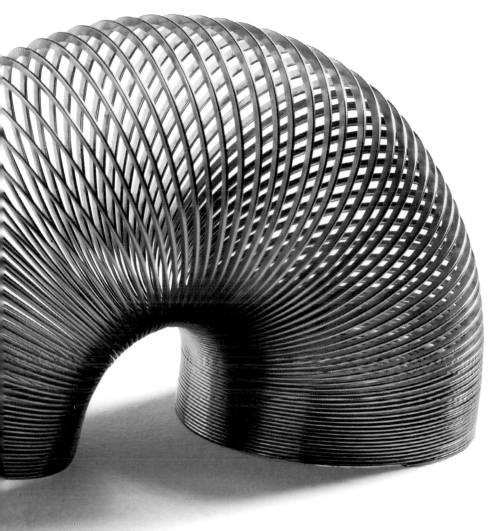

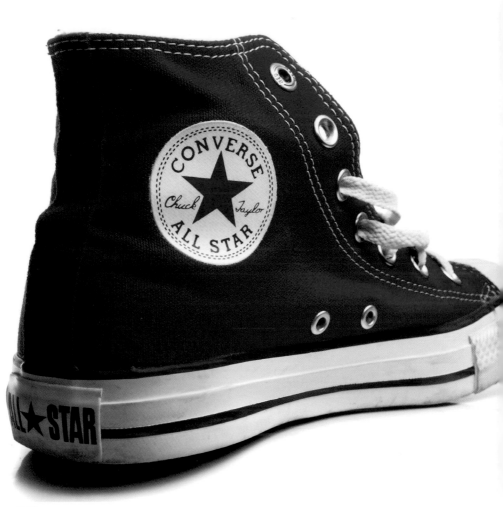

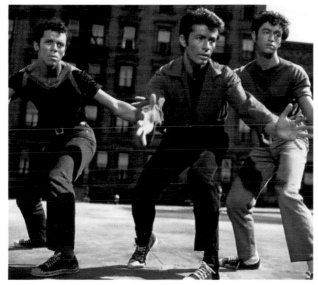

Screen Kicks
Movies like *West Side Story* (left) and *Rebel Without a Cause* helped move sneakers from functional to cool, boy, real cool.

Sneakers

The U.S. Rubber Company created the first comfortable shoe with a rubber sole and canvas tops: Keds. An ad exec coined them "sneakers" because they were so quiet, wearers could sneak up on people. Converse created the first hightop basketball shoes in 1917. Since then, brands like Adidas, Nike (with its signature swoosh), and Reebok have fine-tuned shoe technology for every sport imaginable.

Soap Operas

Daily serialized dramas have been part of U.S. life since Irna Phillips created radio's *Painted Dreams* in the '30s. Phillips and apprentice Agnes Nixon went on to develop TV's *Guiding Light, As the World Turns, All My Children,* and *One Life to Live.* Luke and Laura's wedding on *General Hospital* remains the most-watched daytime drama, with 30 million viewers.

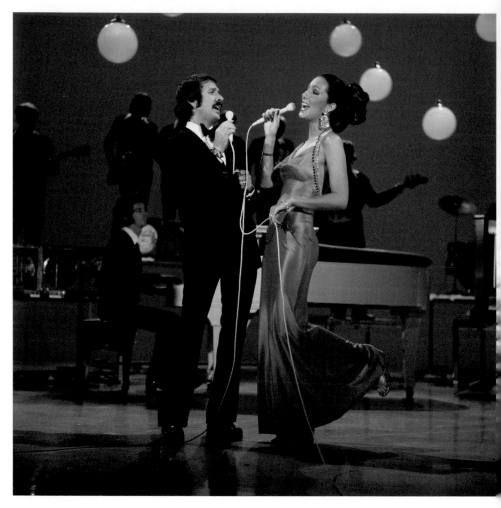

Sonny and Cher

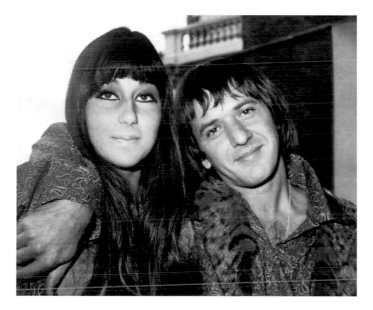

When they met in 1963, she was 16-year-old would-be singer Cherilyn Sarkisian, and he was 27-year-old Salvatore Bono, Phil Spector's song-writing protégé. Within two years, they hit it big with "I Got You, Babe" and "The Beat Goes On." Their fame soared with the '70s *Sonny and Cher Comedy Hour* before they split in 1975.

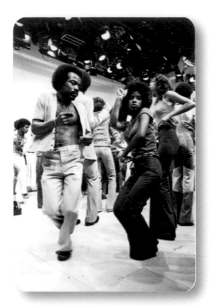

Soul Train

"Soul Train is to *American Bandstand* as champagne is to seltzer," declared the *New York Times.* With ultra-cool Don Cornelius as host, the biggest black artists on stage, and funky dancers workin' the line, *Soul Train* taught teens the Robot, Bump, and Pop-lock. It was, for 35 seasons, "the hippest trip" in town.

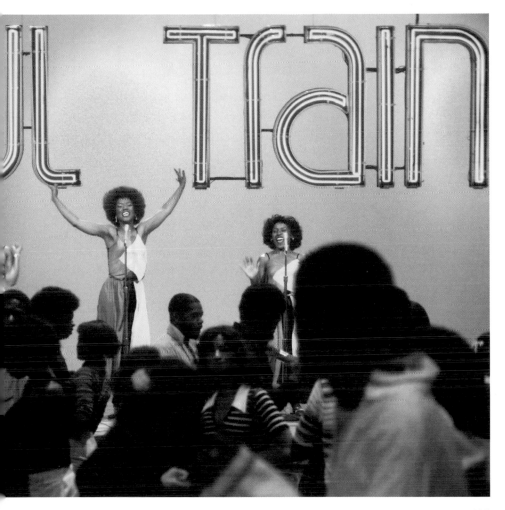

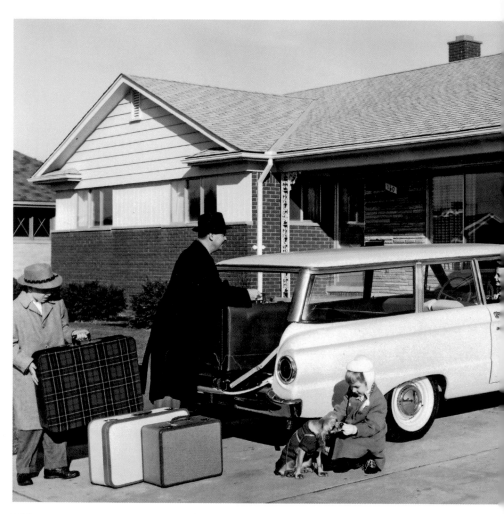

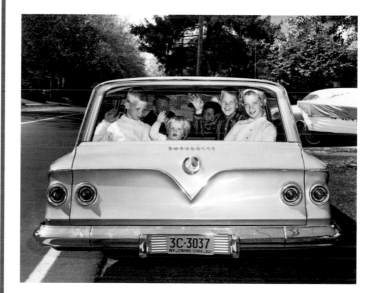

Station Wagons

"Are we there yet?" Station wagons offered ideal transport for boomer families, with two rows of bench seats, plus a third in back for who-ever was in trouble with Mom and Dad. The back could also be folded down for a play area. (Seat belts? Car seats? Never heard of 'em!)

Suntan Lotion

Back when Eisenhower was president, "suntan lotion" was used to attract—not screen—the rays, and an ad revealing a little girl's bare bum glamorized tan lines. The Coppertone ad debuted in 1959, long before anyone had heard about SPF or worried about melanoma. But the cheapest tan was from a mix of baby oil and iodine.

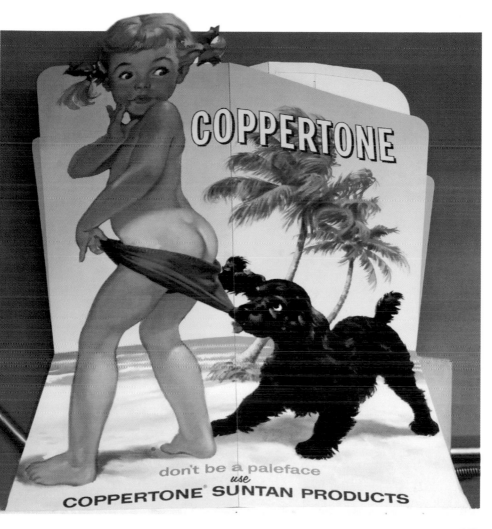

Super Bowl

It wasn't called the Super Bowl at first, but a meeting between the champion of the established National Football League and the upstart American Football League. By the fourth game, in 1971, "Super Bowl" appeared on the tickets—and the event evolved from a game into a veritable national holiday.

Blackout to Sellout

In the first game, the Green Bay Packers smashed the Kansas City Chiefs, 35-10. Despite huge hype and a local TV blackout, there were 30,000 empty seats. Every game since has been a sellout.

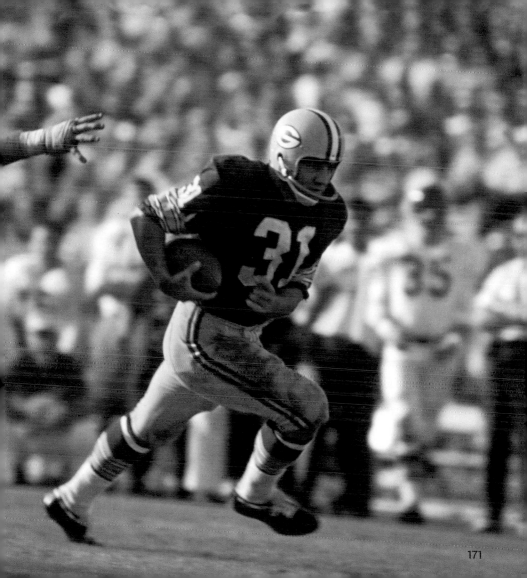

Pssst—Still Love Tab?

A mention in 1985's *Back to the Future* sparked a new generation's taste for Tab. To meet renewed demand, Coca-Cola still produces Tab in limited quantities.

Tab

"How can one calorie taste so good?"
Created to counter the unexpected success
of RC's Diet Rite Cola, Coca-Cola's Tab was
rushed to market in 1963. Tab was made with
saccharin and cyclamates, its name selected
from a computer search of three- and
four-letter words. Though popular, it was
largely replaced by Diet Coke in 1982.

Tang

The unnaturally orange-colored Tang only gained popularity after astronaut John Glenn drank it in orbit. After that, the ads cleverly marketed the powdered breakfast drink "for space men and earth families." Packed with vitamins C and A, sugar, and maltodextrin, Tang contains less than 2 percent orange juice.

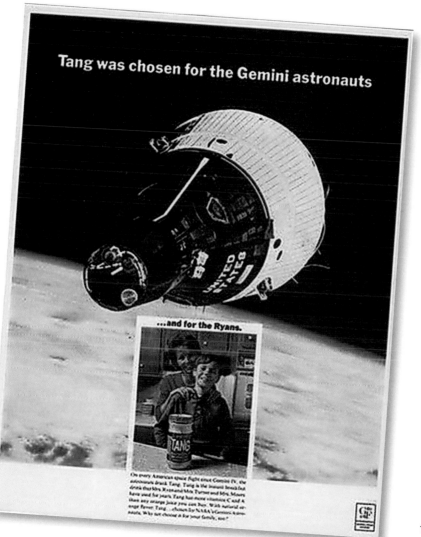

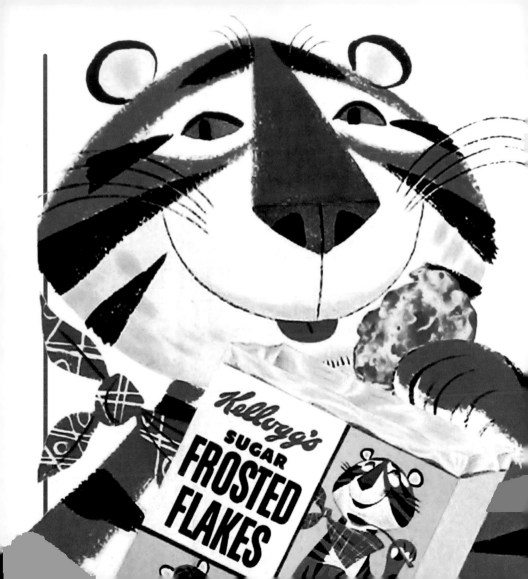

Tony the Tiger

In a 1951 competition, Tony the Tiger beat out Katy the Kangaroo, Newt the Gnu, and Elmo the Elephant to become top "spokescat" for Kellogg's Sugar Frosted Flakes. Although he's since had a bit of work done—a softer, rounder head, a brighter blue nose, and a slimmer physique—Tony is still "Grrrreat!" And processed, boxed cereal is still a boomer staple.

Transistor Radios

The Regency TR1 transistor radio hit the market just before the holidays in 1954, selling out immediately. The Byrds' Roger McGuinn said, "I only had the radio for a short time before I heard Elvis; it was a game changer for me.... I think it's why rock 'n' roll got so big."

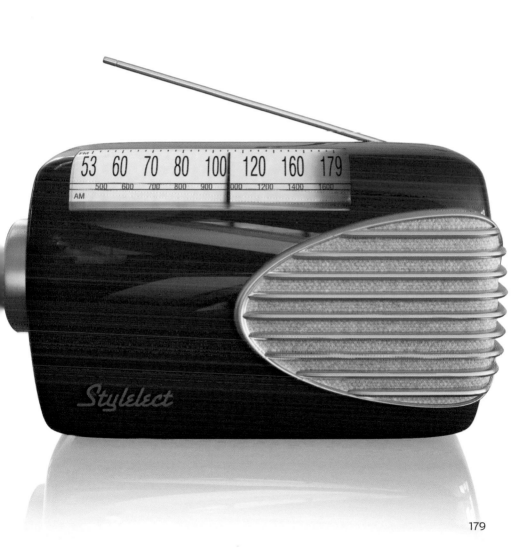

53 60 70 80 100 120 160 179

500 600 700 800 900 1000 1200 1400 1600

FM

AM

Stylelect

Troll Dolls

Too poor to buy a gift for his daughter, Danish woodcutter Thomas Dam carved a troll in 1959, inspired by the legendary trolls who lived in Nordic forests and would bring luck to any human who could catch them. Luck they brought. Americans purchased more than a million in 1964 alone.

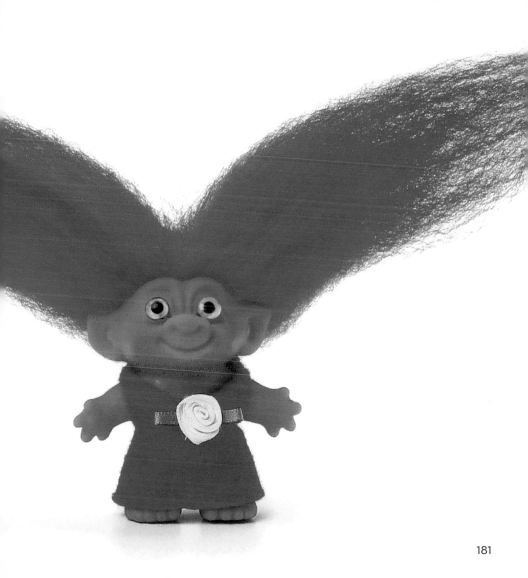

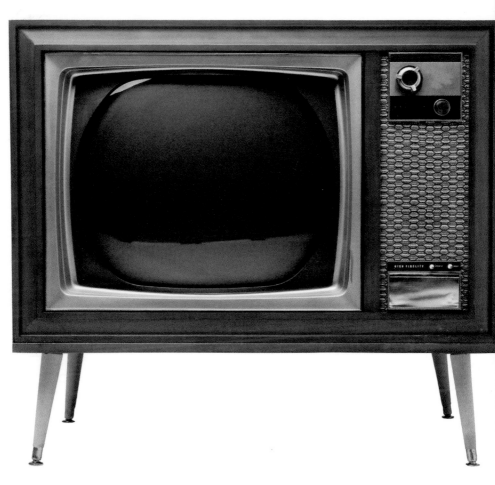

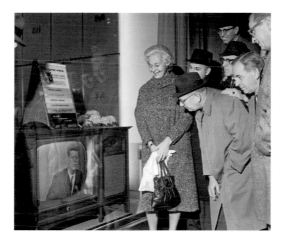

TV

Like the boomer generation, television exploded after World War II. With the emergence of networks ABC, CBS, and NBC, new programming, and lower prices (from $445 in the late '40s to $125 in the '50s), TV ownership in the United States soared from 2 percent in 1948 to 90 percent by 1960.

TV Dinners

Swanson & Sons salesman Gerry Thomas put one and one together (an unsold surplus of frozen Thanksgiving turkeys plus a three-compartment airline-inspired aluminum food tray) and created the first TV dinner in 1953. He received a $1,000 bonus and a raise from $200 to $300 a month.

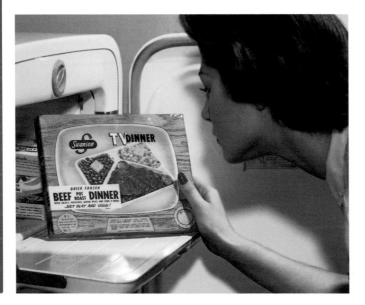

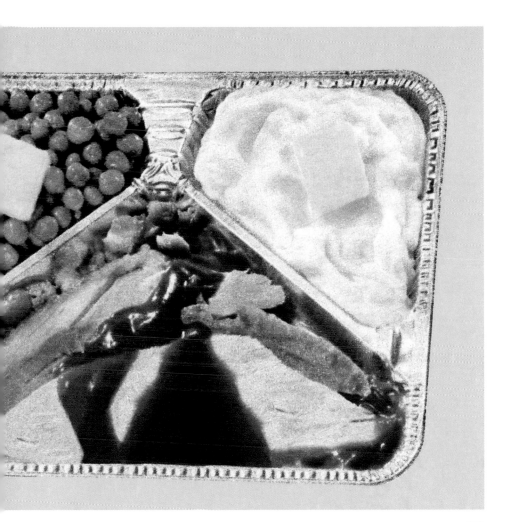

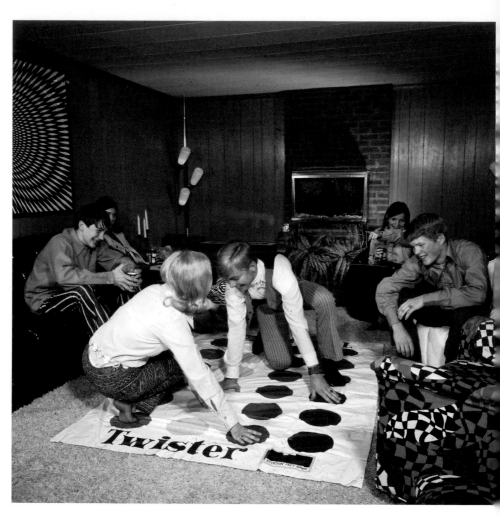

Twister

The original name of "the game that ties you in knots" was Pretzel. Renamed Twister, it didn't sell well until May 1966, when Johnny Carson invited blond bombshell Eva Gabor to play it on the *Tonight Show*. The next day, "people were lined up 50 deep at Abercrombie & Fitch," said Reyn Guyer, who conceived the game.

Sex in a Box?

A competitor accused Milton Bradley of selling "sex in a box." The company responded by positioning Twister as "fun for the whole family."

Miles of Smiles
One million miles of Twizzlers Twists
are produced in a single year. That's
to the moon and back five times.

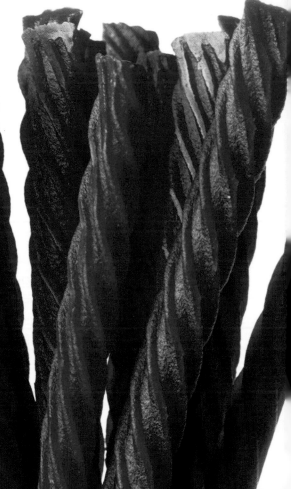

Twizzlers

The red versus black licorice debate
seemed to end with the twisty red Twizzlers.
(Most people never even knew there *were*
black ones.) Despite the high sugar content,
Twizzlers are low in fat, certified kosher, and
on PETA's "vegan candy is dandy" list.

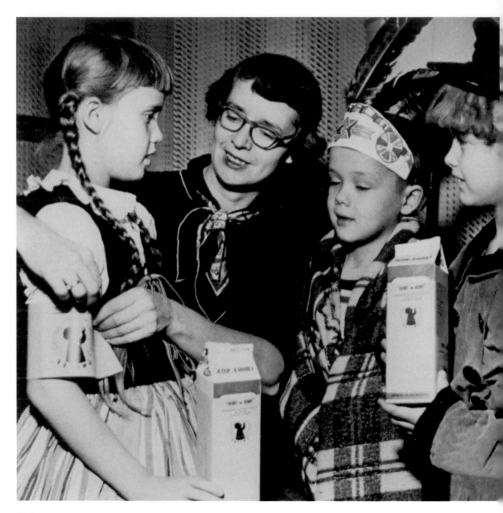

UNICEF

Halloween 1947—another nationwide candy orgy. "Too bad we can't turn this into something good," said Mary Emma Allison, a schoolteacher and mother of three. By 1950, she was sending her costumed kids out to collect coins in milk cartons for UNICEF. Since then, trick-or-treaters have raised nearly $170 million for impoverished children.

View-Master

It was an unlikely encounter in the Oregon caves. A businessman noticed a photographer taking pictures with two cameras taped together to create 3-D slides, and the two men struck a deal. The resulting View-Master debuted as a souvenir at the 1939 New York World's Fair. Contracts to portray Disney films, TV shows, and theme parks followed.

ASTER

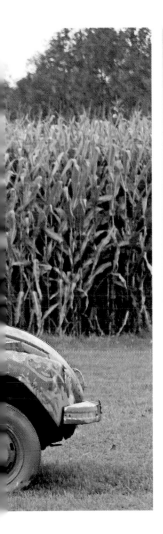

VW Bug

Adolf Hitler commissioned Ferdinand Porsche to design a new *volks wagen,* or "people's car," in 1932. The first VW could fit a family of five and hit 100 kph on the autobahn.

Watergate

Bob Woodward (left) and Carl Bernstein—
portrayed on film (below) by Robert Redford
and Dustin Hoffman—reported the bungled
break-in of the Democratic National Com-
mittee's Watergate offices, which even-
tually led to President Nixon's resignation.
The journalists won a Pulitzer Prize and also
made "[fill in the blank]-gate" part of the
national vocabulary.

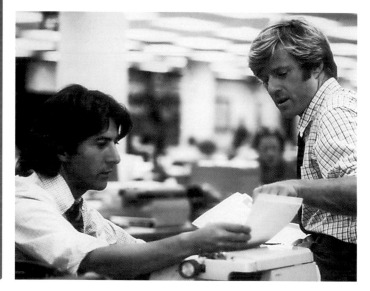

> People have got to know whether or not their president is a crook. Well, I'm not a crook.
>
> —President Richard M. Nixon

The Last Whole Earth Catalog

access to tools

$5

Whole Earth Catalog

"We are as gods and might as well get good at it." So read the purpose of the *Whole Earth Catalog*. Described as "no more radical than Sears Roebuck and *Consumer Reports,* merely attuned to a new market, the sub-economy of dope and rock" (note Mick Jagger, above), the book taught everything from building stone houses to drawing nudes.

Wonderful World of Disney

"It was all started by a mouse,"
Walt Disney once said, referring to his company's
first animated character: Mickey Mouse, created in 1928.
Disney went on to produce cartoons, TV shows,
movies, and his own magical kingdoms.
Call it whimsy. Call it genius. Call it childhood.

Sprinkle of Fairy Dust
The Wonderful World of Disney, taking advantage of the new color TV,
debuted in 1954 and featured all things Disney.

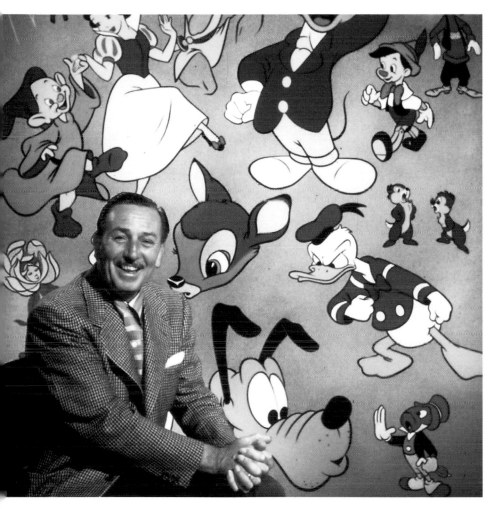

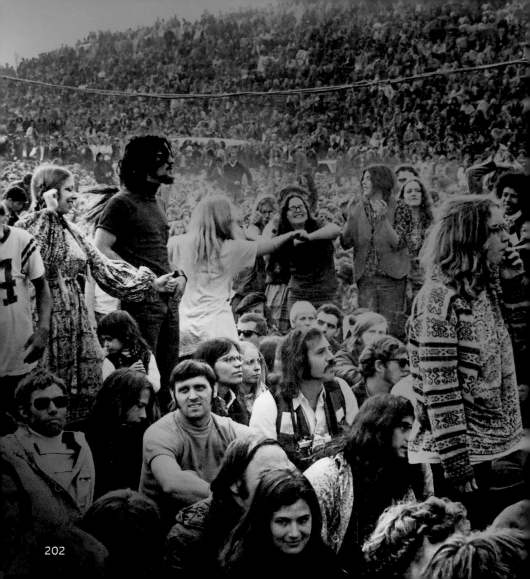

202

Woodstock

The four young organizers printed 100,000 tickets to recoup their investment, but half a million stoned hippies foiled that plan, crashing the party at Max Yasgur's dairy farm. The roads were so jammed that musicians had to helicopter in. Woodstock was the concert that defined the boomer generation.

Credits

Cover, spine, title page: red swoosh—Eric Nyffeler/Doe Eyed

———

Cover, counterclockwise from top left: see p. 158; see p. 85; see p. 126; see p. 90; Getty Images; David Farrell/Redferns/Getty Images; see p. 83; see p. 188; see p. 9; see p. 145.

———

Back cover, from left: GAB Archive/Redferns/Getty Images; see p. 94; see p. 149; Rene Burri/Magnum Photos; see p. 177.

———

p. 2: Everett Collection Historical/Alamy; **p. 3:** Judith Collins/Alamy; **p. 4:** ABC Photo Archives/ABC via Getty Images; **p. 5:** Pictorial Press Ltd/Alamy; **p. 6:** CBS Photo Archive/Getty Images; **p. 8:** (left) NASA/Retna Ltd./Corbis, (right) NASA/Roger Ressmeyer/Corbis; **p. 9:** Corbis; **p. 11:** ClassicStock/Alamy; **p. 12:** (left) Robin Beckham/BEEPstock/Alamy, (right) Minneapolis Star Tribune/ZUMAPress.com/Alamy; **p. 13:** Mario Anzuoni/Reuters/Corbis; **p. 15:** Michael Ochs Archives/Getty Images; **p. 16:** Pictorial Press Ltd/Alamy; **p. 19:** courtesy Everett Collection; **p. 20:** Val Wilmer/Redferns/Getty Images; **p. 22:** William F. Campbell/Time Life Pictures/Getty Images; **p. 23:** Paul Bernius/NY Daily News Archive via Getty Images; **p. 24:** The Shady Baker http://shadybaker.blogspot.com.au; **p. 25:** Mike Morgan; **p. 26:** Tim Boyle/Bloomberg via Getty Images; **p. 27:** Bryce Duffy/Corbis Outline; **p. 29:** Mike Morgan; **p. 30:** Andrzej Tokarski/Alamy; **p. 31:** Interfoto/Alamy; **p. 32:** "The Problem We All Live With," printed by permission of the Norman Rockwell Family Agency copyright © the Norman Rockwell Family Entities; **p. 34:** Michael Kraus Photography; **p. 35:** Pictorial Press Ltd/Alamy; **p. 36:** ArtPix/Alamy; **pp. 38-39:** Doonesbury © 1970 G. B. Trudeau, reprinted with permission of UNIVERSAL UCLICK, all rights reserved; **p. 40:** Mike Morgan; **p. 41:** Pictorial Press Ltd/Alamy; **p. 42:** AF Archive/Alamy; **p. 44:** Fred W. McDarrah/Getty Images; **p. 45:** Keystone-France/Gamma-Keystone via Getty Images; **p. 46:** J. R. Eyerman/Life Magazine/Time & Life Pictures/Getty Images; **p. 47:** Wave Royalty Free/Design Pics Inc./Alamy; **p. 48:** courtesy of Terika Koch; **p. 50:** Bettmann/Corbis; **p. 51:** Marc Tielemans/Alamy; **pp. 52-53:** AF Archive/Alamy; **p. 54:** Chris Willson/Alamy; **p. 57:** Dan Farrell/NY Daily News Archive via Getty Images; **p. 58:** Paul Popper/Popperfoto/Getty Images; **p. 59:** Hulton Archive/Getty Images; **p. 60:** H. Armstrong Roberts/ClassicStock/Everett Collection; **p. 63:** FPG/Getty Images; **p. 64:** Tim Walsh, from his book *Timeless Toys* (Andrews-McMeel, 2004); **p. 66:** courtesy Everett Collection; **p. 67:** CBS Photo Archive/Getty Images; **p. 68:** AP Photo; **p. 71:** Condé Nast Archive/Corbis; **p. 73:** Copyright © Rolling Stone LLC 1987, all rights reserved, used by permission; **p. 74:** ZUMA Press, Inc./Alamy; **p. 75:** courtesy Everett Collection; **p. 76:** Kristoffer Tripplaar/Alamy; **p. 77:** Michael Neelon (misc)/Alamy; **p. 78:** Chris Willson/Alamy; **p. 81:** courtesy Everett Collection; **p. 82:** courtesy of The Strong®, Rochester, New York; **p. 83:** Classic-

204

Stock/Alamy; **p. 85:** AFP/Getty Images; **p. 86:** Mark Shaw/mptvimages.com; **p. 89:** Michael Ochs Archives/Getty Images; **p. 90:** Redfx/Alamy; **p. 91:** Jan Sandvik Editorial/Alamy; **p. 93:** courtesy of Keep America Beautiful; **p. 94:** Jens Mortensen/Galeries/Corbis; **pp. 96-97:** Matthias Kulka/Corbis; **p. 98:** Tim Walsh, from his book *Timeless Toys* (Andrews-McMeel, 2004); **p. 100:** olsonheid; **p. 101:** American Broadcasting Companies, Inc.; **p. 102:** Blank Archives/Getty Images; **p. 103:** Mike Morgan; **p. 104:** Greg Balfour Evans/Alamy; **p. 105:** James Keyser/Time Life Pictures/Getty Images; **p. 106:** Pictorial Press Ltd/Alamy; **p. 107:** (left) courtesy of Hat Horizons; (right) © Art of Drawing/Alamy; **p. 108:** Pictorial Parade/Getty Images; **p. 109:** Marek Mnich/Getty Images; **p. 111:** courtesy Everett Collection; **p. 112:** John Olson/

Time & Life Pictures/Getty Images; **p. 113:** (chart) Susan Appler de los Rios, (ring) Al Freni/Time & Life Pictures/Getty Images; **p. 114:** Michael Ochs Archives/Getty Images; **p. 115:** Andre Jenny/Alamy; **p. 117:** HO/Reuters/Corbis; **p. 118:** Mike Morgan **p. 119:** Bettmann/Corbis; **p. 121:** Neil Leifer/Sports Illustrated/Getty Images; **p. 122:** Mike Morgan; **p. 125:** Pictorial Press Ltd/Alamy; **p. 126:** Scottish Viewpoint/Alamy; **p. 127:** Getty Images; **p. 128:** AF Archive/Alamy; **p. 129:** AF Archive/Alamy; **p. 130:** Ed Clark/Time & Life Pictures/Getty Images; **p. 133:** Al Freni/Time & Life Pictures/Getty Image; **p. 134:** Peter Max artwork © Peter Max; **p. 137:** B Christopher/Alamy; **p. 138:** SSPL/Getty Images; **p. 139:** JP Laffont/Sygma/Corbis; **p. 141:** Lukas Barth/picture-alliance/dpa/AP Images; **p. 142:** Mike Morgan; **p. 145:** David Poller/

ZUMAPress.com/Alamy; **p. 146:** Jessica Nelson/Getty Images; **p. 147:** Lasse Kristensen/Alamy; **p. 149:** SuperStock; **p. 150:** Lynn Goldsmith/Corbis; **p. 151:** Bettmann/Corbis; **p. 152:** Roger Ressmeyer/Corbis; **p. 153:** Tim Walsh, from his book *Timeless Toys* (Andrews-McMeel, 2004); **pp. 154-155:** courtesy Everett Collection; **p. 157:** Laurent Hamels/PhotoAlto/Corbis; **p. 158:** Sergio Azenha/Alamy; **p. 159:** courtesy Everett Collection; **p. 161:** ABC via Getty Images; **p. 162:** CBS via Getty Images; **p. 163:** Keystone Pictures USA/Alamy; **p. 164:** Michael Ochs Archives/Getty Images; **p. 165:** Michael Ochs Archives/Getty Images; **p. 166:** Bettmann/Corbis; **p. 167:** SuperStock/Corbis; **p. 169:** Witold Skrypczak/Alamy; **p. 171:** Focus On Sport/Getty Images; **p. 172:** evemilla /iStockphoto; **p. 175:** courtesy Rick & Tyler Schemmel/Petsonalities; **p. 176:**

courtesy of the Advertising Archives; **p. 178:** James A. Weil; **p. 179:** iStockphoto; **p. 181:** Tim Walsh, from his book *Timeless Toys* (Andrews-McMeel, 2004); **p. 182:** Yuri Kevhiev/Alamy; **p. 183:** Bettmann/Corbis; **p. 184:** William Gottlieb/Corbis; **p. 185:** Vetta/Getty Images; **p. 186:** Hulton Archive/Getty Images; **p. 187:** courtesy of the Advertising Archives; **p. 188:** iStockphoto; **p. 190:** courtesy Allison family: Mary Jean Thomson, Margaret "Mickey" Allison, and Monroe Allison; **pp. 192-193:** Luxio/Alamy; **p. 194:** Bob Caddick/Alamy; **p. 195:** courtesy Off the Wall Vinyl Decor; **p. 196:** courtesy Everett Collection; **p. 197:** Ken Feil/Washington Post/Getty Images; **p. 198:** Ted Morrison; **p. 199:** Mike Morgan; **p. 200:** Walt Disney/courtesy Everett Collection; **p. 201:** Alfred Eisenstaedt/Time Life Pictures/Getty Images; **p. 202:** Interfoto/Alamy.